How to Draw
Lifelike Portraits
from Photographs

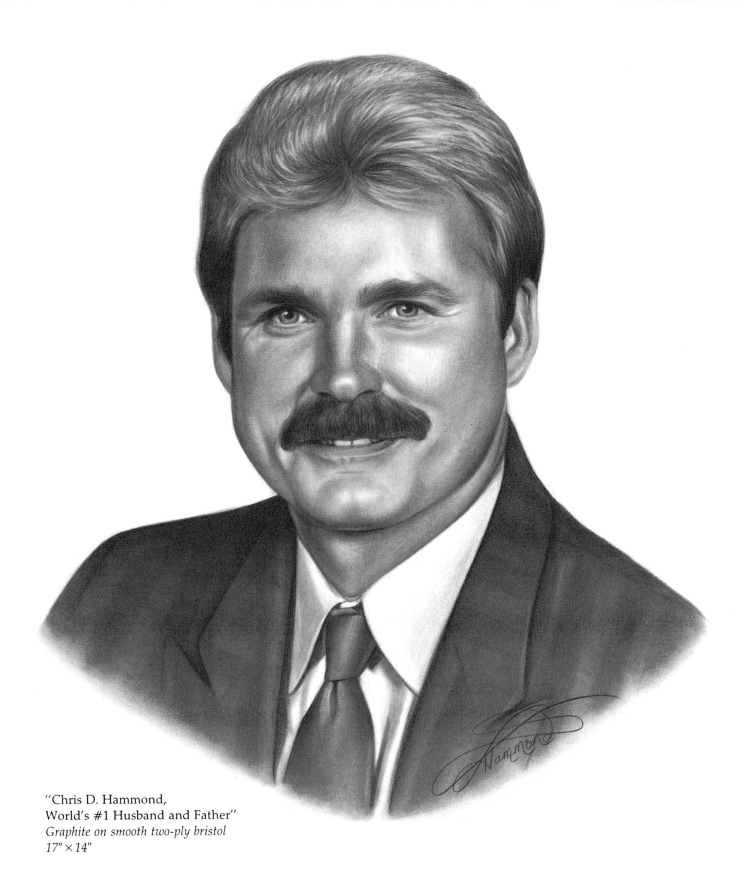

"Chris D. Hammond,
World's #1 Husband and Father"
Graphite on smooth two-ply bristol
17" × 14"

How to Draw
Lifelike Portraits
from Photographs

LEE HAMMOND

NORTH LIGHT BOOKS
Cincinnati, Ohio

About the Author

Polly (Lee) Hammond is a Kansas City-based illustrator who specializes in portraiture. Her expertise in the art field includes everything from detailed, pictorial billboard illustration, technical illustration, fine art drawing and painting, to complete commercial art studio experience. Portraiture will always be her main focus.

Lee attended the University of Nebraska and has worked as a Police Composite Artist for both Kansas and Nebraska. She has been certified through NAMTA (National Art Materials Trade Association).

She now resides in Overland Park, Kansas, where she maintains her own business, Hammond Illustration and Art Instruction. She has a full teaching schedule and is very busy with a commissioned portrait and illustration service.

Lee is married to Chris Hammond, and is the mother of three children, Shelly, LeAnne and Christopher.

How to Draw Lifelike Portraits from Photographs. Copyright © 1995 by Lee Hammond. Printed and bound in the United States of America. All rights reserved. No part of this book may be reproduced in any form or by any electronic or mechanical means including information storage and retrieval systems without permission in writing from the publisher, except by a reviewer, who may quote brief passages in a review. Published by North Light Books, an imprint of F&W Publications, Inc., 1507 Dana Avenue, Cincinnati, Ohio 45207. 1-800-289-0963. First edition.

This hardcover edition of *How to Draw Lifelike Portraits from Photographs* features a "self-jacket" that eliminates the need for a separate dust jacket. It provides sturdy protection for your book while it saves paper, trees and energy.

Other fine North Light Books are available from your local bookstore or direct from the publisher.

04 03 02 01 00 99 10 9 8 7 6

Library of Congress Cataloging-in-Publication Data

Hammond, Lee
 How to draw lifelike portraits from photographs / Lee Hammond.
 p. cm.
 ISBN 0-89134-635-X
 1. Portrait drawing—Technique. 2. Pencil drawing—Technique. 3. Drawing from photographs. I. Title.
NC773.H28 1995
743'.42—dc20 94-48193
 CIP

Edited by Kathy Kipp
Designed by Brian Roeth
Cover illustration by Lee Hammond

Thanks to each artist for permission to use artwork.

All work presented in this book has been rendered in graphite, on two-ply bristol, unless otherwise stated.

METRIC CONVERSION CHART		
TO CONVERT	**TO**	**MULTIPLY BY**
Inches	Centimeters	2.54
Centimeters	Inches	0.4
Feet	Centimeters	30.5
Centimeters	Feet	0.03
Yards	Meters	0.9
Meters	Yards	1.1
Sq. Inches	Sq. Centimeters	6.45
Sq. Centimeters	Sq. Inches	0.16
Sq. Feet	Sq. Meters	0.09
Sq. Meters	Sq. Feet	10.8
Sq. Yards	Sq. Meters	0.8
Sq. Meters	Sq. Yards	1.2
Pounds	Kilograms	0.45
Kilograms	Pounds	2.2
Ounces	Grams	28.4
Grams	Ounces	0.04

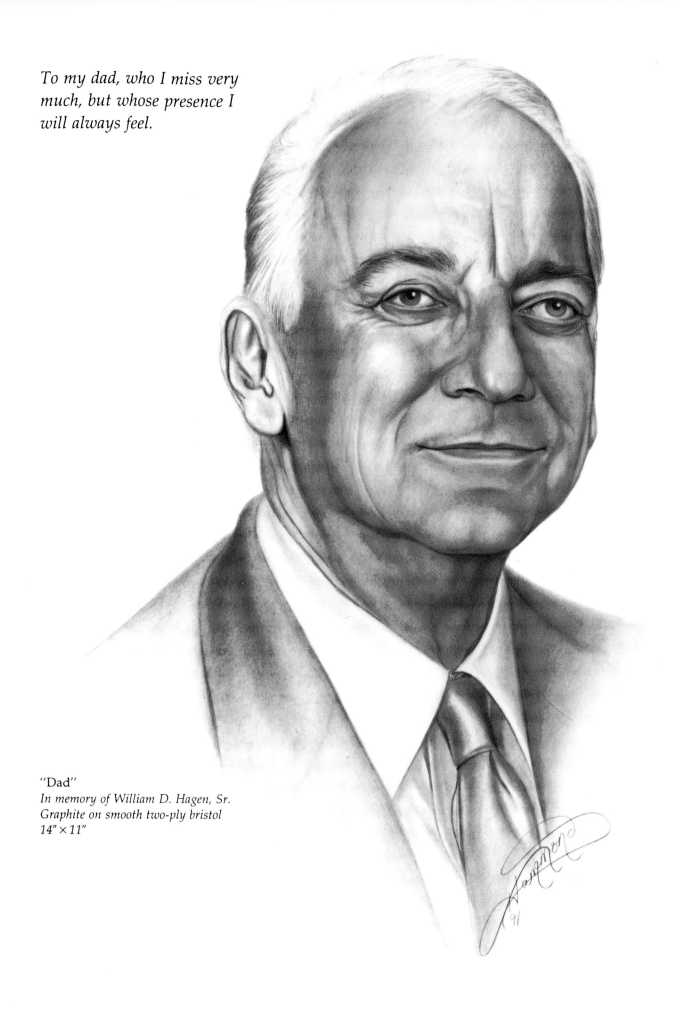

To my dad, who I miss very much, but whose presence I will always feel.

"Dad"
In memory of William D. Hagen, Sr.
Graphite on smooth two-ply bristol
14" × 11"

Acknowledgments

The successful completion of this book, and the essence within it, truly belongs to the wonderful students that I have had the honor of teaching throughout the past fifteen years. Without their undying support, encouragement, enthusiasm and friendship, this book would surely have remained just a dream for me.

I thank all of them from the bottom of my heart for their help and patience as I pieced all of this together. But most of all, I thank them for the wealth of information that they always provided me through their questions as I helped them pursue their love of art. I'm sure they will never know just how much they have "taught" me too.

A huge thank-you must also be directed to my wonderful family (and favorite subjects), especially my fantastic husband and children. I realize that living with an artist is not an easy thing to do, and we have had plenty of difficult times. I will learn to live with the idea that their memories of me will probably be that of my back, as I faced my drawing table or typewriter, day after day and year after year. I hope they will know in their hearts how much they have always been loved.

Finally, I would like to express my gratitude to the incredible people at North Light Books, who made me feel so much at home and like part of the "gang." A nicer group of people to work with, I'm sure, could not be found. Thanks so much for your help and support, and most of all, your friendship.

CONTENTS

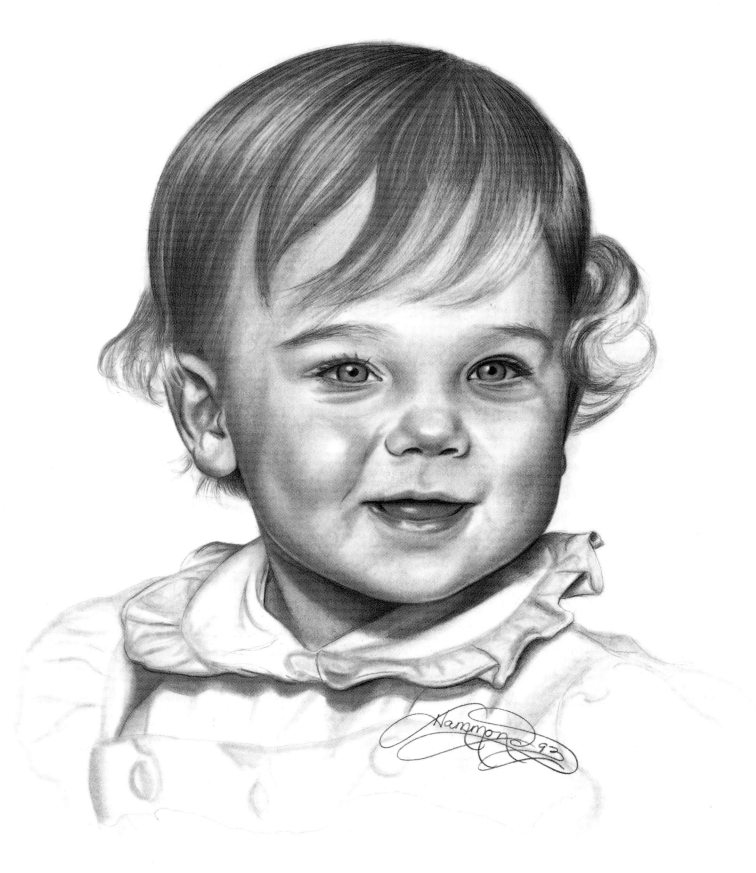

"Shelly's First Portrait"
Graphite on smooth two-ply bristol
14" × 11"

Introduction

Like most artists, I have been drawing since childhood. I followed the same artistic steps as every child, from stick people to exaggerated features of my family and friends. As I progressed in age, my attempts at drawing became more of a challenge since I was no longer satisfied with the "normal" progression of my renderings. I wanted to draw like my grown-up sister, who is an exceptionally gifted artist to this day. School projects seemed too general for me, and their insistence on creative expression, impressionism or abstraction, although interesting to me as concepts, did not suit my natural artistic desire. That desire was to capture people and objects realistically on my paper. That need was not met through the many years of schooling, art classes and workshops that I put myself through. So began the long, hard process of teaching myself.

Over the years, my artwork finally began to take the shape that I wanted it to, and I began to sell my work and to teach the very technique that I had developed. This book is the combined information that I have accumulated through years of teaching and being taught. Many of the issues addressed are actual questions raised by my students. It is a book that can instruct the self-learner or one that can be used in a classroom situation. This is the very book that I wish had been available to me when I was learning!

To get the most out of it, take this book step-by-step, in the order in which it is presented, whether you are a beginner or advanced. I promise you will see results not only in the way you draw, but also in the way you see things. Practice, and lots of it, will be the key to your success. The lessons within, combined with your desire, will lead you to some of the best drawing you have ever done.

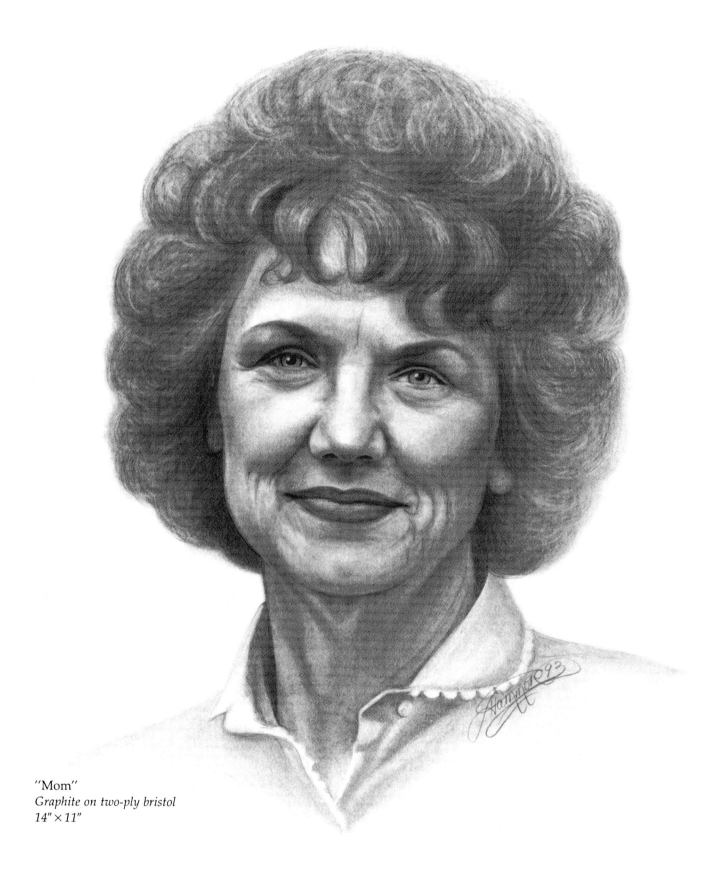

"Mom"
Graphite on two-ply bristol
14″ × 11″

You Can Do It! Here's Proof

Agood portrait is the product of many important elements. The artist must have a good understanding of the subject matter, a keen eye for details and the effects of lighting, and the ability to put it all down on paper with the illusion of realism.

The portrait on the facing page shows what can be done with an ordinary snapshot out of the family photo album. After the successful completion of this book, you too, will be able to capture your memories in the form of beautifully drawn, realistic-looking portraits.

On the following pages are some drawings I have collected from my students. In each set, the first example shows how the student was drawing before taking my classes, and is typical of how most people draw at the beginning stages of their artistic development.

When looking at a student's beginning work, you'll notice certain characteristics that are common to everyone's beginning attempts. First, the student takes a simplistic approach when drawing the face and the hair. There is usually an extreme overuse of hard lines, without smooth transitions in tone. This creates a harsh, outlined look. Second, there's an overall lack of understanding of the facial features.

It is my goal, through this book, to familiarize you with the small but telling details of each feature. This knowledge will carry over into your work, providing you with the necessary skills to achieve realism in your drawings.

Now look at the second example in each set of student portraits. You can clearly see the difference in the student's abilities. By following the easy-to-do exercises as they are presented in this book, you, too, will achieve great results.

Before

This is a drawing done by an eleven-year-old girl. Although it is quite good for a person of her age, it shows all of the characteristics of the struggling beginner.

The outlining of the facial features is a key problem, which I find with most beginners' work. The eyes and lips are simplified, and need to be more accurate in their shapes and details. There is a lack of shading, which makes the drawing seem unreal and almost cartoon-like.

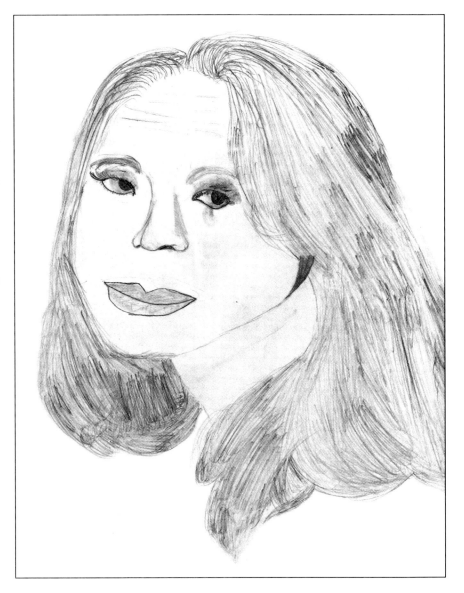

Artwork by Erin Horner, age 11 (a practice drawing from a magazine photo)

After

This is the artist's second attempt, using the same photo reference. It shows the improvement in the artist's ability to "see" the subject and render it more realistically.

The features are no longer harshly outlined; instead, tone is creating their shapes. Blending now defines the contours of the face, and the hair appears dark and very full.

Before

This drawing was also done by a student before taking my class. Although there has been an attempt at some shading to create form and roundness, the underdeveloped features keep the work from looking real. The hair, rather than appearing thick and full, is nothing more than a bunch of pencil lines.

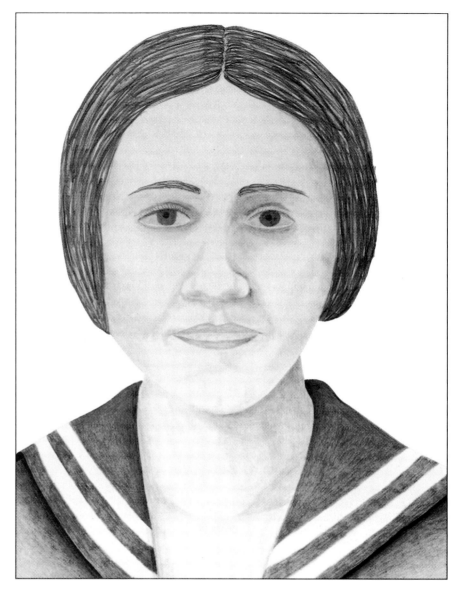

Artwork by Veva Haas
(beginning drawing)

After

It is hard to believe that this portrait was done by the same artist, and even harder to believe that this was the *first* drawing done by her after studying the material in this book. Although the portraits are not of the same subject this time, the vast improvement in artistic ability is immediately apparent. Tones are blended, edges are softened, the hair has depth and volume, and the subject's personality is revealed.

Before

Here is another example of what a student did before and after my classes. Both drawings were created from the same photo reference. She brought the drawing at right with her on the first day of class, so I could see what she had been doing in her college classes. Again, you can see the simplistic approach that was taken. It has a "sketchy" appearance, but the student wanted a more polished look to her work.

Notice the rough use of line and the lack of accuracy in the likeness. The features seem poorly proportioned and incorrectly positioned.

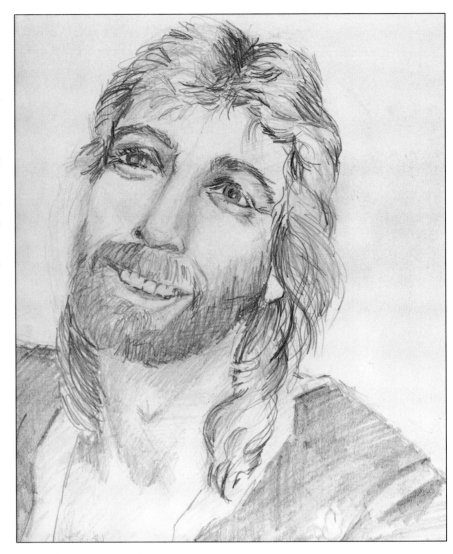

Artwork by Angie Wolf
(portrait of Kenny Loggins, first attempt)

"Kenny
Loggins"
*Artwork by
Angie Wolf
14" × 11"*

After

Once again, the second drawing shows what the student was able to achieve after studying the lessons in this book. The likeness of Kenny Loggins is much more accurate, and the blending and shading is more realistic in ap-

pearance. The features are correctly proportioned and positioned. The hair and beard now have depth and volume, plus a softness and shine that is not seen in the first sketchy attempt.

I love the way the portrait has been double matted. This helps give the drawing a finished, professional look.

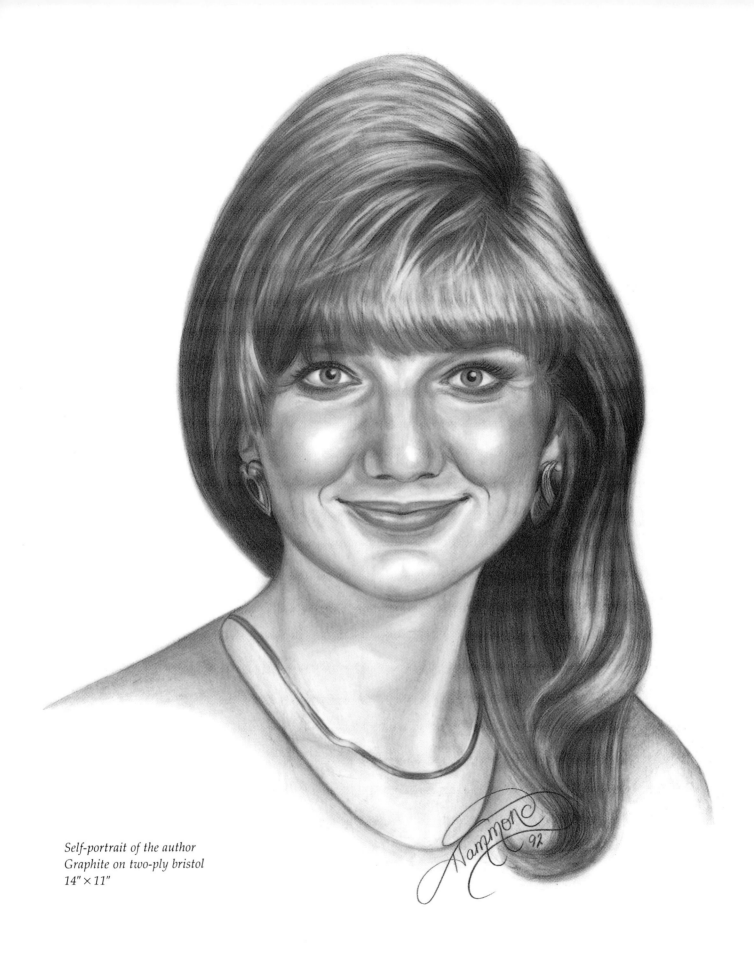

Self-portrait of the author
Graphite on two-ply bristol
14″ × 11″

Blending: The Key to Realistic Portraits

Drawing is a very personal thing, an accumulation of information, education and experiences, all combined with our own special, unique personalities. Because of this, no one style of art or any particular drawing technique can be considered "right or wrong," but merely different.

Where some styles and subject matter lend themselves to impressionistic, bold statements and applications, the drawings in this book will concentrate on a gradual, smoothly blended appearance. I feel this particular style of drawing best replicates the smooth, subtle characteristics of skin, thus providing us with "realism" in our portrait work.

The key to this style of drawing can be summed up in two words: *gradual blending*. This means a smooth application of tones, from very dark to extremely light, with a very gradual blend in between. It should be so gradual that you cannot see where one tone ends and another begins.

We will be concentrating on three major concepts throughout this book, concepts that will apply to everything you draw: *shapes*, *lights* and *darks*. Training your eye to see these things correctly takes time, so we will approach each one singly and slowly. Once you can see things as just "shapes," your accuracy will automatically improve.

But the most important goal is *blending*. Blending will make any shape you draw appear realistic if applied accurately. The questions of where and how shading should be placed and blended will be explained and demonstrated thoroughly, and the mystery behind the "Hammond Blended Pencil Technique" will be revealed!

Learning to Blend With Graphite

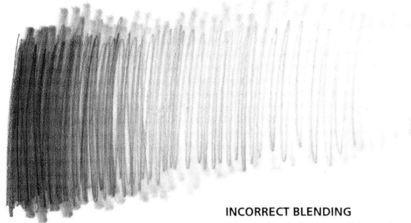

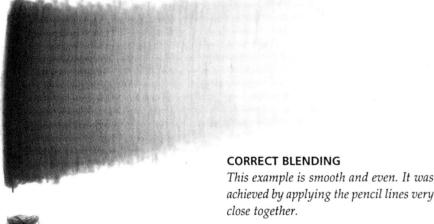

INCORRECT BLENDING
Notice the obvious pencil lines that weren't blended out. The tones are choppy and rough, not even and gradual.

CORRECT BLENDING
This example is smooth and even. It was achieved by applying the pencil lines very close together.

Always hold the tortillon at an angle to keep from flattening out the tip.

The key to the blended pencil technique is the gentle blending of tone from dark to light. There should be no choppiness or interruption of tone. You should not be able to see where one tone ends and another begins.

The smoothness is achieved by applying your pencil lines softly, and always in the same direction. Build your tones slowly and evenly. Lighten your touch gradually, as you make the transition into your lighter areas. Smooth everything out with a blending tortillon, moving in the same direction you used to place your pencil tone, beginning with the darks and blending out to light.

Always use the tortillon at an angle. Using the tip will cause the end to push in and become blunt. If this should happen, you can repair it by sticking the end of a straightened paper clip inside of it and pushing the tip back out.

Do not throw your tortillons away as they become dirty! Save them, and divide them into groups according to how much graphite they have on them. A very black tortillon will be just what you need to blend out a dark area later, like a dark head of hair or a background.

Always use a fresh tortillon for the light areas, and don't be tempted to use the same ones over and over again to conserve. They are inexpensive; I buy them by the gross so I never have to hunt for a clean one when I need it.

MATERIALS NEEDED FOR SMOOTH BLENDING

- **Smooth bristol board or sheets, two-ply or heavier**

 This paper is very smooth (plate finish) and can withstand the rubbing associated with this technique.

- **5mm mechanical pencil with 2B lead**

 The brand of pencil you buy is not important, since they all use the same lead. Although they all come with an HB lead, replace it with a 2B.

- **Blending tortillons**

 These are spiral-wound cones of paper. They are *not* the same as harder, pencil-shaped stumps that are pointed at both ends. Tortillons are better for the blending technique. Buy both large and small.

- **Kneaded eraser**

 These erasers resemble modeling clay, and are essential to this type of drawing. They gently "lift" highlights without ruining the surface of the paper.

- **Typewriter eraser with a brush on the end**

 These pencil-type erasers are handy because their pointed tips can be sharpened. They are abrasive and erase stubborn marks, but can also rough up the paper.

- **Horsehair drafting brush**

 These brushes will keep you from ruining your work by brushing away erasings with your hand and smearing your pencil work. They will also keep you from spitting on your work while blowing the erasings away.

- **Pink Pearl eraser**

 These erasers are meant for erasing large areas and lines. They are soft and nonabrasive, and will not damage your paper.

- **Workable spray fixative**

 This is used to seal and protect your finished artwork. It can also be used to "fix" an area of your drawing, so it can be darkened by building up layers of tone. The word "workable" means you can still work on your drawing after it has been sprayed.

- **Drawing board**

 It is important to tilt your work toward you as you draw, to prevent distortion from working flat. A board with a clip to secure your paper and reference photo will work the best.

- **Portfolio case**

 This is a large, flat carrying case to hold your projects, papers and drawing board. This is not to be confused with a presentation case that has acetate pages inside.

- **Art or tackle box**

 These are essential for carrying all of your drawing supplies.

- **Ruler**

 You'll need a ruler for graphing and measuring features.

- **Templates (stencil guides), both circle and ellipse**

 These are used for accurately drawing the irises and pupils of the eyes.

- **Magazines**

 They will be your best source for practice photos. By collecting magazine pictures and filing them into categories, you will have your own reference library. This will help you study various poses, ages and character types.

The Five Elements of Shading

To render something realistically, the artist must fully understand the lighting on the subject and the five elements of shading. The form of any object is created by the correct placement of lights and darks, the five elements of shading, and the gentle blending of the tones together.

Every tone on the object you are drawing should be compared to black or white. But how do you know how dark to draw something? Using a simple five-box scale of values can help you decide on the depth of tone. Each one of the tones on the scale represents one of the five elements of shading. For example, tone number three on the value scale —medium gray—corresponds to shading element number three on the sphere—the halftone (halfway between white and black).

1—Cast Shadow. This is your darkest dark, and should be made as close to black as possible, as seen in box number one on your scale. This is the shadow that the object you are drawing is "casting" on the surface on which it lies. The shadow is the darkest where the object and the surface touch, and then it lightens gradually as it gets farther away from the object.

2—Shadow Edge. This is the dark gray, and corresponds with number two on your scale. This is *not* the edge of the object, it is where the object is receding from the light, and is on the opposite side of the light source.

3—Halftone. This is the medium gray, or number three on your scale. This is the true color of the object, without the effects of direct light or shadow. It is neither light nor dark, so it is called a halftone.

4—Reflected Light. This is the small light edge seen around the object, particularly between the cast shadow and the shadow edge. This is really the light bouncing back from the surrounding surfaces. It is the light that makes the object appear round and solid, and tells us that there is a back side to it. *Reflected light is never bright white!* It is closer to a halftone, like box number four on the scale.

5—Full Light. This is where the light hits the object full strength. Full light should be represented by the white of the paper. The gray areas should be blended into this area very carefully, so no hard edges are created.

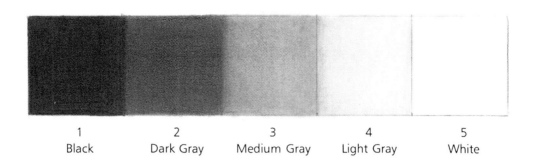

1	2	3	4	5
Black	Dark Gray	Medium Gray	Light Gray	White

Notice how the five elements of shading on this sphere correspond to the five tonal values on the scale above. The light is coming from the front, a little off to the right.

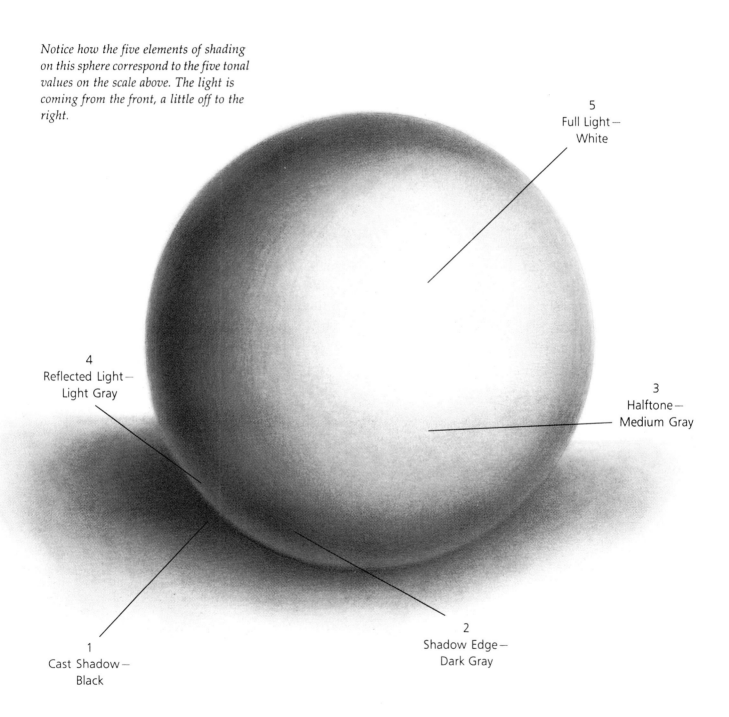

5
Full Light—
White

4
Reflected Light—
Light Gray

3
Halftone—
Medium Gray

1
Cast Shadow—
Black

2
Shadow Edge—
Dark Gray

Correct Blending Techniques

Before you begin drawing actual objects you should get a good feel for your tools and materials. I recommend that you first draw some blended-tone swatches, as shown on page 12, to help you learn to control your blending. Start with your darkest tone on one side and gradually lighten the tone as you continue to the other side. Do as many as you need to, until you feel proficient at it.

Once you begin to draw actual objects, such as the cylinder shown below, use the following guidelines to help you.

1. Soft edge: This is where the object gently curves and creates a shadow edge. It is not harsh, but a gradual change of tone.

2. Hard edge: This is where two surfaces touch or overlap, creating a harder edged, more defined appearance. I do not mean *outlined*! Be sure to let the difference in tones create the edge.

3. Application of tone: Always apply your tones, whether it be with your pencil or tortillon, *with* the contours of the object. Follow the curves of the object, with the shading parallel to the edges, so you can blend into the edge, and out toward the light. It is impossible to control blending if you are cross blending and not following the natural edges and curves.

4. Contrast: Don't be afraid of good solid contrasts of tone. Always compare everything to black or white. Use your five-box value scale to see where the gray tones fit in. Squinting your eyes while looking at your subject matter obscures details and helps you see the contrasts better.

The sphere, the egg and the cylinder are all important shapes to understand if you want to draw portraits. If you can master the five elements of shading on these simple objects first, drawing the human face will be much easier.

Additional Helpful Hints

- Uneven tone can be corrected by forming a point with your kneaded eraser, then *drawing in reverse*. Use a light touch and gently remove any areas that stand out darker than others. Light spots can be filled in lightly with your pencil.
- Areas that need to be extremely dark can be sprayed with fixative and the darks built up in layers. Be sure that any erasing that needs to be done is done first, before spraying.
- Use your typewriter eraser to crisp up edges and remove any overblending.

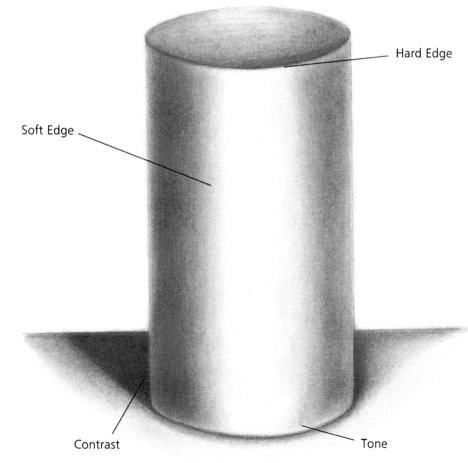

Hard Edge

Soft Edge

Contrast

Tone

Three Basic Steps of Rendering

All rendering requires three basic steps. First is an *accurate line drawing*, or outline of your subject matter. An outline is merely the outside shape, whereas a line drawing includes the interior details. It is the foundation of your drawing and acts as a guide for placing tones. Second is the identification and placement of *lights and darks* and placing them in as puzzle pieces, much like a map. And third is, the *blending* of all your tones together, smoothly and gradually. As you study and practice the shapes below, refer back to the Five Elements of Shading on pages 14-15.

I suggest that you draw these shapes at least three times each, with the light source coming from a different direction each time (top, left side, right side). This may seem repetitious, but *practice* is the key to successful portrait drawing.

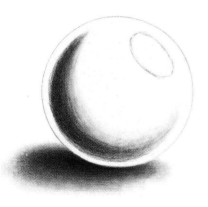

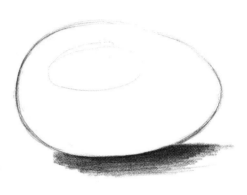

Step 1 ACCURATE LINE DRAWING
Once the object's shape has been drawn accurately, you must identify the light source. The area on the object where the light shines the brightest can be lightly outlined. You'll erase those lines later. Since all shadows are opposite the light source, you can also place your cast shadow. You now have your lightest light and your darkest dark.

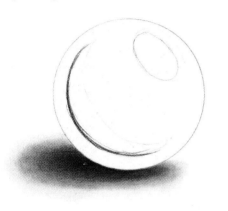

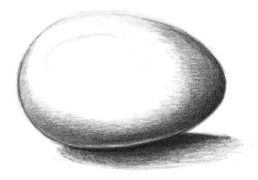

Step 2 PLACEMENT OF TONES
Placement of the shadow edge must be done carefully. Pencil lines should be applied smoothly going "with" the shape of the object. Make sure to leave room for the reflected light. Keep it low, where it belongs; this is a shadow, it cannot be up in the light.

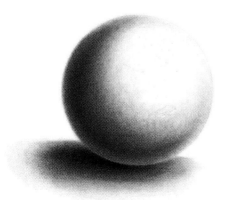

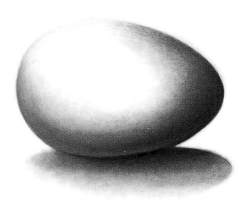

Step 3 BLENDING
Blend with your tortillons to create your halftones. Blend "with" the object's shape from dark to light. Make sure it is a smooth blend. Allow the tone to create the edge of the object, and remove any outline that may be showing. Anything with an outline around it appears flat. Correct any unevenness in your blending. Light "spots" can be gently filled in to hide them. Dark spots can be gently "lifted" with a pointy piece of your kneaded eraser.

The Puzzle Piece Theory: A Guide to Seeing Shapes

Before you begin any type of blending on your artwork, it is very important to give yourself a firm foundation to build from. This is achieved by giving yourself an outline and *accurate line drawing* first.

The easiest and most educational way to draw a portrait from a photo is by using a graph. A graph is simply a tool that divides your photo into smaller, workable boxes to draw in. To help you understand how a graph works, I have developed a graph exercise that's fun to do, like a puzzle.

At right is a series of numbered boxes that contain black and white nonsense shapes. By drawing these shapes in the corresponding numbered boxes on the empty graph at right, you will prove to yourself that you *can* draw. This exercise teaches you to see just shapes, and shapes alone. *Do not* try to figure out what you are drawing. As soon as we become aware of what the subject matter is, we start to draw from our memories, instead of from what is right in front of us.

No matter what we are drawing, we should learn to see the object as many individual shapes, all interlocking like a puzzle. This can be referred to as "mapping." If one of the shapes we are drawing does not lead us to the next one, fitting together, we know that our drawing is inaccurate.

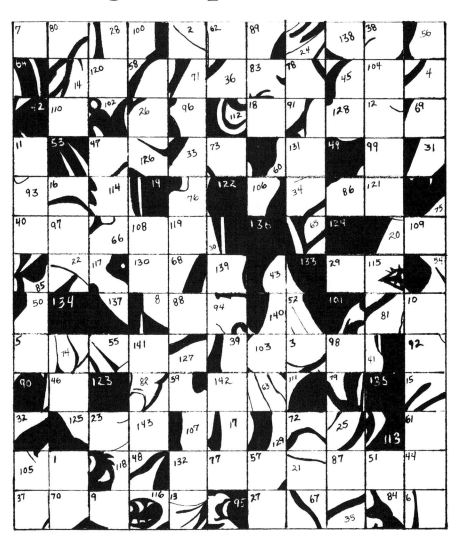

Once these nonsense shapes are drawn in their correct positions on the graph at right, the subject will be revealed.

1	2	3	4	5	6	7	8	9	10	11
12	13	14	15	16	17	18	19	20	21	22
23	24	25	26	27	28	29	30	31	32	33
34	35	36	37	38	39	40	41	42	43	44
45	46	47	48	49	50	51	52	53	54	55
56	57	58	59	60	61	62	63	64	65	66
67	68	69	70	71	72	73	74	75	76	77
78	79	80	81	82	83	84	85	86	87	88
89	90	91	92	93	94	95	96	97	98	99
100	101	102	103	104	105	106	107	108	109	110
111	112	113	114	115	116	117	118	119	120	121
122	123	124	125	126	127	128	129	130	131	132
133	134	135	136	137	138	139	140	141	142	143

Make a photocopy of the empty graph, then draw in the nonsense shapes exactly as you see them in the puzzle at left. Be sure to draw each shape in its corresponding numbered box.

Putting It All Together in a Portrait

In this portrait you can clearly see how the five elements of shading apply to the human face. Note how the roundness of the face is accentuated by the shading and the use of shadow edges and reflected light. The light source in this case is coming from the front.

The simple shapes we have studied can also be seen. The egg shape can be seen in the overall shape of the human head. The sphere can be seen in the facial features such as the cheeks and the nose. And the cylinder can be seen in the shape of the neck.

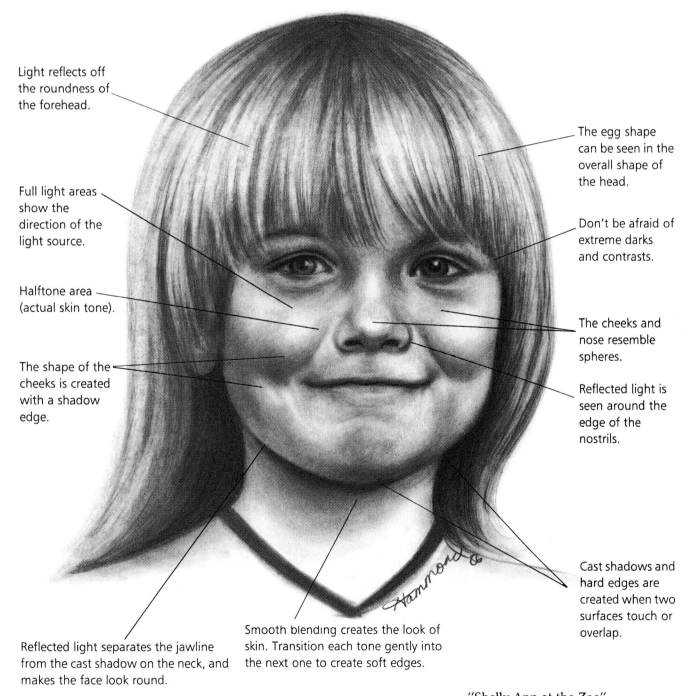

Light reflects off the roundness of the forehead.

Full light areas show the direction of the light source.

Halftone area (actual skin tone).

The shape of the cheeks is created with a shadow edge.

The egg shape can be seen in the overall shape of the head.

Don't be afraid of extreme darks and contrasts.

The cheeks and nose resemble spheres.

Reflected light is seen around the edge of the nostrils.

Cast shadows and hard edges are created when two surfaces touch or overlap.

Reflected light separates the jawline from the cast shadow on the neck, and makes the face look round.

Smooth blending creates the look of skin. Transition each tone gently into the next one to create soft edges.

"Shelly Ann at the Zoo"
Graphite on two-ply bristol
10" × 8"

Important Points to Remember

1. Keep blending extremely smooth and gradual, with no choppiness.

2. Always use a tortillon at an angle to protect the tip.

3. Use your five-box value scale to judge your tones. Compare everything to black or white.

4. Keep in mind the five elements of shading and their placement.

5. Always begin your work with an *accurate line drawing*.

6. Anything with an outline around it will appear flat and unrealistic.

7. Look for the basic shapes: the sphere, the egg and the cylinder.

8. See your shapes as interlocking puzzle pieces.

9. Practice is the key to success.

10. Repetition is the key to learning.

11. Repetition is the key to learning.

12. Practice!

13. Practice!

14. Practice!

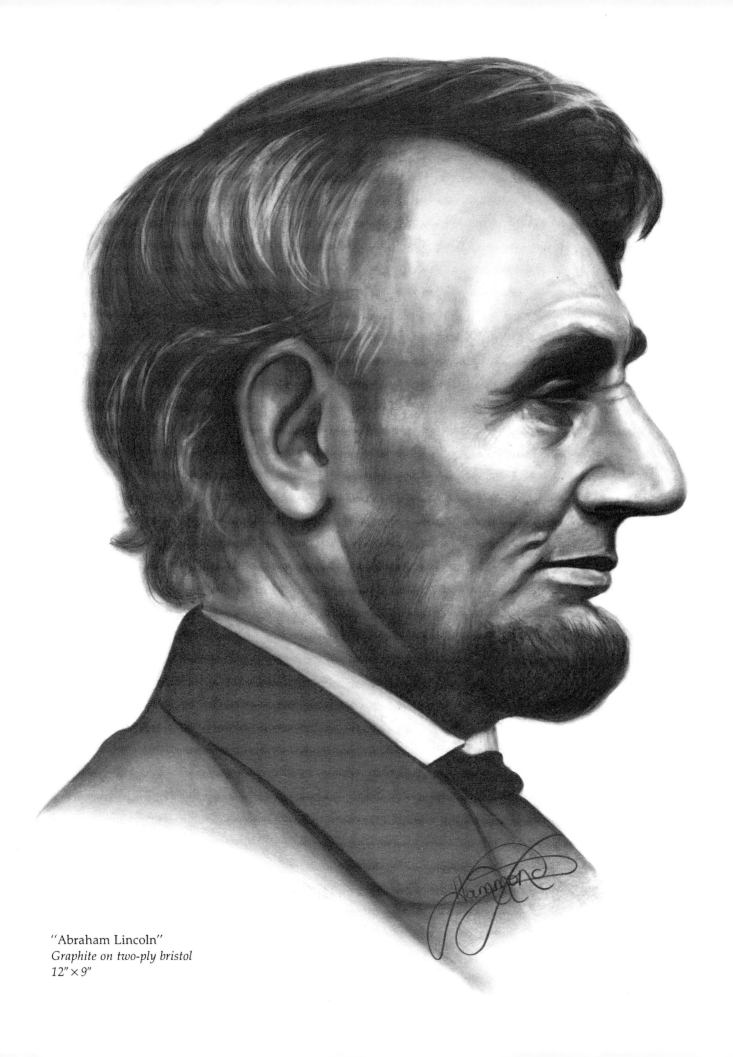

"Abraham Lincoln"
Graphite on two-ply bristol
12" × 9"

Drawing the Nose

Why should we begin with the nose? Although it may seem unusual to begin there, it really is the most logical next step. Because of the nose's similarities to the sphere, it is an excellent way to learn the elements of shading and how they apply to all the facial features. Since *blending* is the key element to this entire style of drawing, starting with the nose gives you the opportunity to practice the shading and blending principles you learned in chapter two.

The nose is not one single object like the sphere, but is a continuation of the face, a projection. It is similar to the sphere in its roundness and how it reflects light.

The nose is also important to the overall size and scale of all of the other facial features. It is in direct proportion to the size and shape of the eyes, mouth and ears. A nose that is drawn inaccurately will affect the total outcome of the portrait and ruin the likeness. By drawing the nose, you will learn to gently connect everything together on the face, seeing the face as a whole, with everything correctly related and blended together.

You will study the proportions of the head, the placement of the other features, and achieving a likeness later, after you have fully explored and conquered the blending technique.

If you can draw a really good nose, you are on your way to some very good portrait drawing!

Start With a Sphere

Drawing a nose is easy if you first break it down into its component shapes. The drawings in the middle show how the sphere shape can be seen in the shape of the nose. But unlike the sphere, which is one continuous shape, the nose has multiple protrusions, or "planes." Each sphere and plane contains its own set of at least four of the five elements of shading.

First, you must identify where your light source is in order to place your shadows and tones correctly. On the illustration of the nose below, the full light area is on the front of the nose, with the shadow areas on the opposite side. Every photo reference you use will have its own light source, so study it carefully before you begin to draw.

While studying the examples, refer to your five-box value scale to see how dark the tones of the nose are. On every nose, the darkest area will be inside the nostril. This is a cast shadow, since the front of the nose is blocking the light. Like all cast shadows, it becomes lighter as it comes toward the light.

The shadow edges can be seen on the side of the "ball" of the nose, under the nose, between the nostrils, and around the side of the nose where it connects to the face.

Reflected light, which is important to show roundness, can be seen clearly around the edge of the nostrils. Any surface that has

a "lip" or rim will reflect light. There is also more subtle reflected light anywhere you find a shadow edge, since it is this light that separates shadow edges from cast shadows.

▶ *The nose has many of the simple shapes we practiced in chapter two. If you look carefully, you will see egg shapes and spheres within the overall shape of the nose. Gradual blending of tones gives the smooth appearance of skin.*

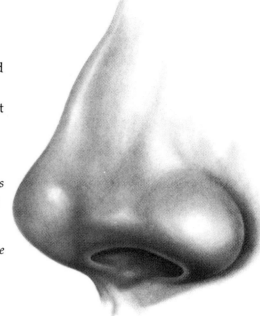

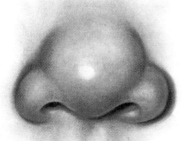

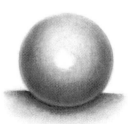

This nose can easily be seen as three individual spheres.

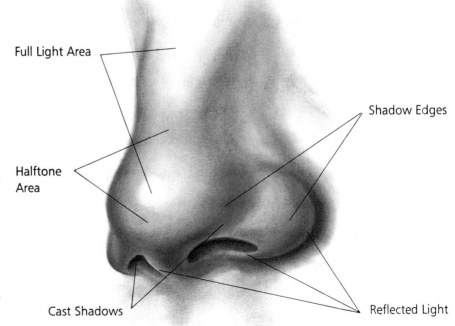

Full Light Area

Halftone Area

Shadow Edges

Cast Shadows

Reflected Light

The five elements of shading can be seen on every area of the nose.

Use Blending to Give Form

Never use hard lines to draw the shape of the nose. This will make your drawing seem cartoon-like. Remember that anything with an outline goes "flat."

The nose has many surfaces or planes. By sketching a *chiseled* look, you can see how these planes make up the nose, and how these shapes angle into the face.

The nose is a continuation of the face; it is not separate and sitting on top of it. The use of smooth blending, from dark to light, will give the illusion of depth and form, which is necessary to achieve realism.

Your light sources may vary drastically from photo to photo; some photos will be brightly lit, and others will be dark and shadowy. The light source can make a huge difference in your contrasts and the way you must draw them. The darker the shadows, the brighter the full light area will appear. A soft, diffused light source will make the difference in tones less obvious.

The drawing at far right shows some extremes in contrasts, due not only to the light source, but also to the darker skin tones. Don't be afraid to achieve good solid darks, if that is what your photo reference calls for.

When drawing the nose, include the side of the face as a foundation for the nose to build from. Using the cast shadows on the surrounding areas will also help describe the nose's shape.

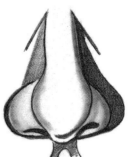

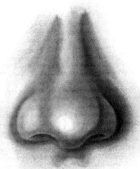

Never outline the nose—it will look like a cartoon.

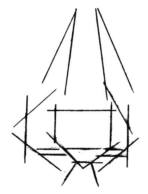

A chiseled nose, drawn with angled lines, shows the planes.

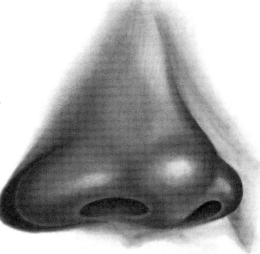

A blended nose gives the illusion of form.

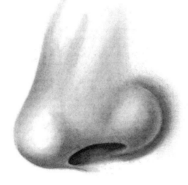

The nose in bright lighting has less contrast between the darker and lighter tones.

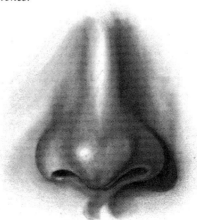

A nose in heavy shadow has more contrast.

Look for extremes in tones and contrasts.

Drawing the Nose Step by Step

One of the keys to drawing a lifelike nose is to look for hard and soft edges. *Soft edges* are created by the roundness of the nose and are seen as shadow edges. *Hard edges* are seen in the nostril area, because a hard edge is formed when two surfaces overlap. A hard edge is also seen where two surfaces "touch," as where the nose meets the face. However, this edge is more subtle and lighter in tone.

Repetition and practice are the key to learning how to draw, especially when you are teaching yourself. Look through magazines for facial reference pictures, and draw as many noses in as many different poses as you can find. The next pages will teach you how to graph off these pictures to achieve an accurate line drawing. It will also be beneficial to draw from the illustrations in this book, since sometimes it is easier to "draw from a drawing" at first, to study the blending.

Step 1 ACCURATE LINE DRAWING
Remember, before you can begin any blending, you must always start with an accurate line drawing. This stage is very important. No blending should be applied until your basic shapes are perfected. It is extremely difficult to correct the shape of a drawing once the blending process has been started.

First, look for the spheres and planes in the shape of the nose and lightly sketch the basic shape. Include guidelines for the highlighted areas.

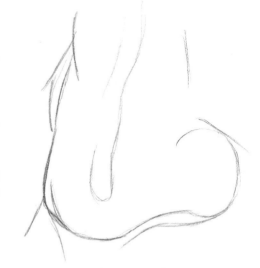

Step 2 PLACE THE TONES
When placing your tones, they should first be assigned a shape, much like that of a puzzle, with each tone connected to another. This goes for both light and dark areas. These "tone shapes" will give you a guideline for your blending, and help maintain the shape of the nose. Your drawing at this stage will resemble a map.

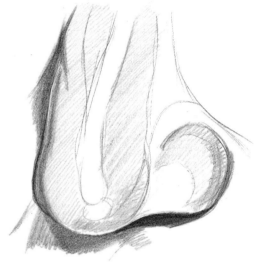

Step 3 BLEND
The blending stage should be done very carefully to keep your tones smooth. Be sure that your original puzzle piece shapes no longer show. Pull any highlight areas out with your kneaded eraser, rather than drawing around them.

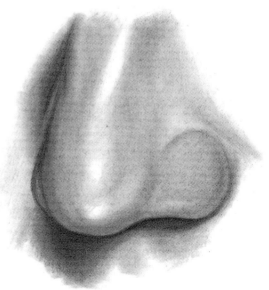

How to Graph a Facial Feature

Now that you are familiar with the Puzzle Piece Theory and the box method of drawing shapes (see pages 18-19 if you need to review), you are ready to draw the nose by using a graph. Before you start, you will need to make a clear acetate overlay with a box graph on it.

Purchase a clear acetate report cover (the kind we used in school to put book reports in). With a *permanent*, fine-point marker and a ruler or T square, draw two large rectangles on the acetate. Divide one into 1-inch squares, the other into ½-inch squares. Be sure that your lines are very straight and parallel, so your

boxes will be perfectly square and equal in size.

Slip a photo or magazine picture inside your acetate graph. Do you see how the image is divided into equal squares? *Very lightly*, draw another graph, in pencil, on your drawing paper. It should contain the same size and number of boxes necessary to capture the size of the photo you are working from. With these graphs, you are now ready to create an accurate line drawing.

These graphs will also help you draw from the illustrations in this book. Just place the graph over the one you want to work from. Use the 1-inch graph for im-

ages that do not have a lot of detail, and the ½-inch graph for images that have many small details. (The smaller the box, the less room for error.)

You can also use your graph to enlarge or reduce your photo reference. To make something *bigger*, make the squares on your drawing paper larger than the ones on your graph. For instance, if your graph is ½-inch, placing 1-inch squares on your paper will make your drawing twice as big as the photo. You can reduce by reversing the process. The shapes you are drawing will be the same, as they relate to the squares they are in.

A ½-inch graph works well for highly detailed images.

A 1-inch graph is fine for images with few details.

Graphing the Nose

Graphing a photograph will help you see your subject as just "shapes." Study the photos below to see how the overall shapes of the nose, as well as the shadow shapes within, have been transferred into a line drawing. Using these photos as a guide, draw these noses for practice.

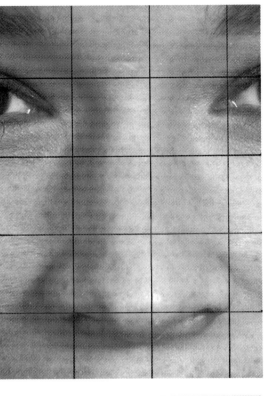

I recommend this graph size, although you can make a graph with any size boxes as long as the boxes are truly square (a T square will help).

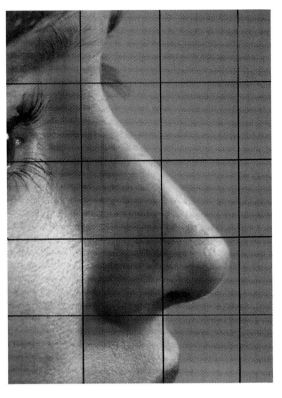

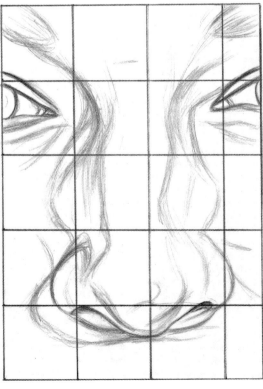

Remember to draw your graph lines very lightly on your drawing paper so they can be erased easily when your shapes are accurate. (These graphs have been darkened so you can see them more clearly.)

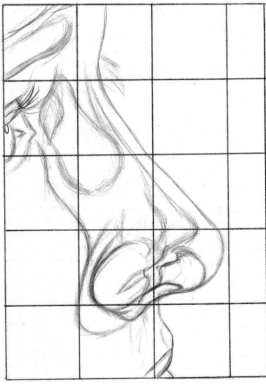

Practice Drawing the Nose

Here are some more opportunities to practice the principles that we have learned so far. Not only are the poses different in both examples, the lighting is too. Watch carefully for subtle changes in tone. Squinting your eyes as you look at the drawings will make the tones more obvious in their contrasts, and things like reflected light will be easier to see. Try to imitate the tones as closely as possible. Refer to your five-box value scale for tonal comparisons if you need to.

When blending, use a fresh tortillon if yours are starting to get a little soiled. Going into a light area with a dark tortillon will not give you the soft results you want. Save the dark ones for use in dark areas of your artwork.

Fine tuning your artwork is the last stage. This is where you correct any errors or inconsistencies in your blending. Light areas that show up in your blend should be filled, and dark spots lightened with the kneaded eraser. Don't stop until you are satisfied with the appearance of your work.

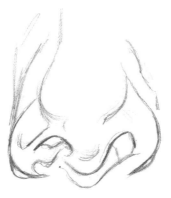

ACCURATE LINE DRAWING
This is the most important element of your artwork. Without accuracy at this stage, everything else will be incorrect. Place your acetate graph over these drawings to help you see the shapes.

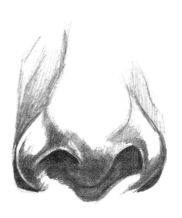
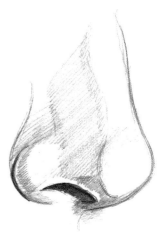

PLACEMENT OF TONES
Assign all of your shapes a tone. Check your five-box value scale if you need to. Do you see how these shapes all interlock like a puzzle?

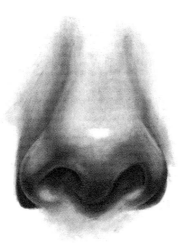

BLENDING
Blend your tones from dark to light, following the contours of the nose's shapes. Keep your blending smooth, just as you did in the sphere exercise on page 17.

How the Nose Relates to the Other Features

Accurate placement of the facial features is essential for obtaining a good likeness. The nose acts somewhat like a "center weight" for all of the other facial features. If the nose is not drawn in the proper shape and size, it will throw the rest of the features off.

As a general rule, the nose is measured from the bridge, between the eyes, *down* to underneath the nostrils. That distance will be equal to the distance from the bottom of the chin, *up* to the nostrils.

The base of the nose will also give a reference point for the earlobes, if you measure across. And the space between the eyes, above the nose, is equal to one eye-width. This width will also give you the width of the nostril area.

Go through magazine pictures. Find faces that look straight ahead, without any tilt or turn to the head, and see how these general rules actually apply.

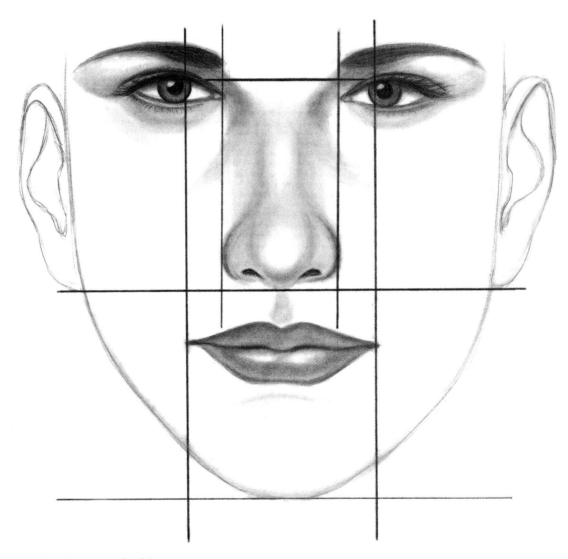

See how the face, from the eyes to the chin, can be divided in half *with the base of the nose as the center?*

Important Points to Remember

1. The nose is made up of soft edges where it gently curves, and hard edges where the planes overlap or touch.

2. Look for the basic shapes within the nose.

3. Look for your light source and the shadow placement.

4. Use your five-box value scale to apply your tones.

5. Look for the reflected light around the edge of the nostrils.

6. Make sure you have an accurate line drawing *before* you begin blending.

7. Draw from the illustrations in this book for practice.

8. Never use outlines.

9. Study the relationship of the nose to the other features.

10. Practice!

11. Practice!

12. Practice!

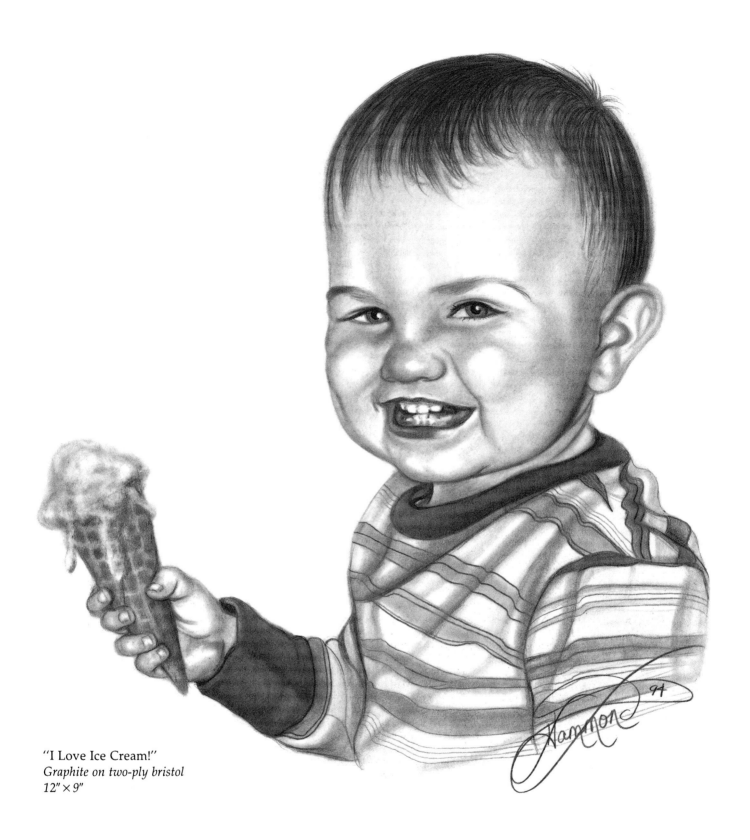

"I Love Ice Cream!"
Graphite on two-ply bristol
12″ × 9″

Drawing the Mouth

Because the mouth does not seem very complex, especially when closed, we have a tendency to simplify it in our drawings. The mouth, much like the nose, must be seen as *shape*, with all the elements of shading applied to it. Study the examples of the mouth on the following pages, and see if you can identify where the five elements of shading are. Since the mouth does not project outwardly off of the face as much as the nose, there will not be as dark a cast shadow below it, so the darkest dark, or number one on your five-box value scale, will be seen in the corner of the mouth, which is called the *pit*. The shadows below the mouth remain fairly light, like those of a halftone. The highlight or full light area of the lower lip is easy to see. Reflected light, which is always the hardest to see, can always be found on the upper lip, just above the edge where the two lips touch.

Drawing Women's Lips

When looking at the lips and their tones, you will see that the upper lip is always darker than the lower one. This is due to the angles at which the lips protrude. The upper lip, although pushed out farther because of the teeth, angles "inward" so it receives less light. The bottom lip, on the other hand, has a downward thrust that acts like a shelf to reflect light. This is why, when the mouth is shut and the lips are together, you will see reflected light on the upper lip, along the edge where the two lips touch. The light is being bounced back off the lower lip.

Never draw the mouth and lips with a harsh outline around them. As we learned with the nose, this will make them appear flat and unreal. Instead, allow the tone of the lips to come up and create an "edge." Sometimes women's lips will appear outlined due to their lipstick, but keep the edge looking soft by blending the edge into the lip.

It's not necessary to draw every line and crease you see in the lips. Usually the one in the middle of the lower lip is the most noticeable and helps give the lip its shape. The bright highlight on the bottom lip helps the lips look moist and shiny.

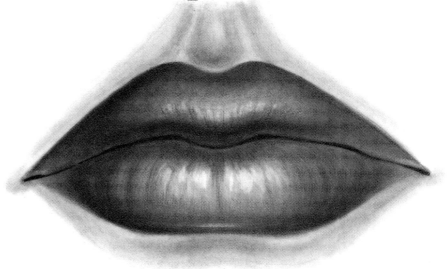

The lips are composed of toned shapes, not harsh outlines.

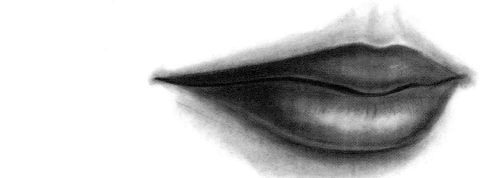

The upper lip is always darker than the lower one.

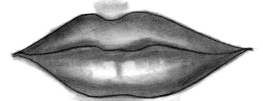

Never outline the mouth and lips.

The upper lip angles "in" while the bottom lip angles "out."

Shading and Shaping the Teeth

The mouth becomes more complicated when the lips are open, allowing the teeth to be seen. Each tooth *must* be drawn accurately in size, shape and placement, or it has a profound effect on the likeness of your subject. Pay attention to the fact that the teeth are not really bright white, like we wish they were, but have shadows on them created by the lips. The actual shapes of the teeth are defined by drawing the gumline above them and the dark, triangular shapes below them. This will create the shape of the teeth gently instead of drawing around each tooth separately. The separation is not dark, but very subtle.

Although lips are often very rounded, there are many angles that are created by their shape. When a mouth is seen from a three-quarter view as the one above, it's important to study these angles to prevent ourselves from drawing the mouth too straight on (our minds will want to draw everything from a head-on view). Sometimes the turn of the face is very slight. By drawing a line down the center of the mouth, you can clearly see that there is more of the mouth showing on the left side than on the right. If we fail to identify that small detail, we will probably draw the mouth too straight on and ruin the likeness.

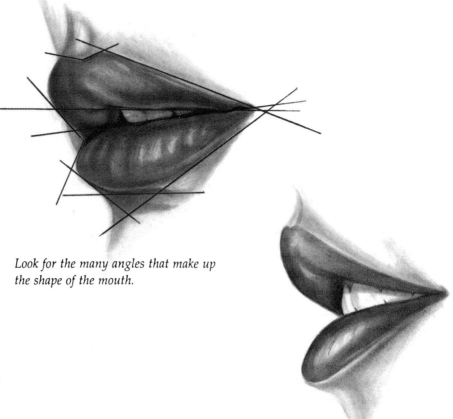

Look for the many angles that make up the shape of the mouth.

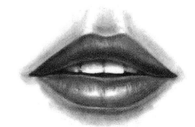

See how the teeth are shaped by the gumline above? You do not see a hard line between each tooth. The upper lip casts a subtle shadow across the teeth.

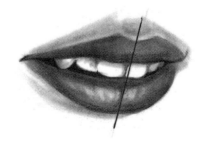

The teeth are also shaped by the dark spaces below them. Placing a center point helps keep the proportions accurate.

The highlight on the lower lip makes it look moist.

Drawing Men's Lips

Men's lips are usually much less defined than women's. Lipstick can make women's lips look a lot darker than they naturally are, making the shadows of the mouth harder to see. Because a man's lips will appear lighter in color and less defined, the shadows that make up the lips' shapes are more noticeable.

The lips are a part of the continuous shape of the face. They really are nothing more than an area of darker pigment that protrudes slightly. Because they stick outward a little bit, they cast shadows and they reflect light.

When drawing men's lips, rather than trying to create "lips," look for the shadows above and below them. Sometimes it is the shadow itself that defines the shape, and there is no actual outline to the lip at all.

There may also be times when the lips are barely discernable and their characteristics very subtle. In cases like these we will always have the tendency to try to put more into our drawing than is really there. Again, this is due to our minds telling us how a mouth "should" look, rather than drawing what we actually see.

Study your photo carefully before you begin to draw. See the lips as they actually are. If they are subtle and undefined in the photo, they should be subtle and undefined in your artwork too. Draw only what you *see*.

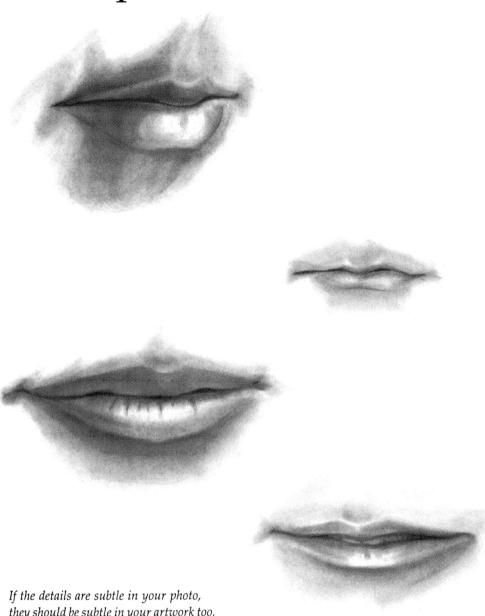

If the details are subtle in your photo, they should be subtle in your artwork too.

Drawing the Mouth Step by Step

Now let's try drawing the mouth in three easy steps. Follow the same procedure as you did for the nose, beginning with your line drawing, applying your tones, and then blending your values and adding details.

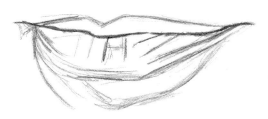

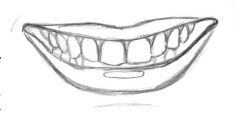

Step 1 ACCURATE LINE DRAWING
Begin with an accurate line drawing. This is where all of your shapes create the foundation for your entire drawing. Be sure that the teeth are accurate in shape, size and placement. Highlights and shadows also should be drawn in as shapes.

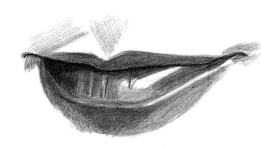

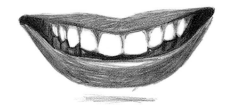

Step 2 BLOCKING IN TONES
Block in your tones. Use your value scale to judge the depth of tone. Look for the shadows on the teeth, especially the lower ones. On the example at right, they can barely be seen, but they are still very important to the overall look of this mouth. Add any lip creases or lines that are important to the shape and character of the particular mouth you are drawing.

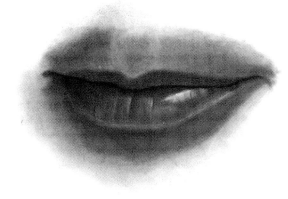

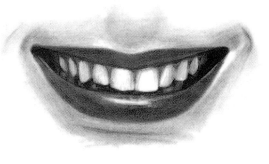

Step 3 BLENDING AND DETAILING
Blend out your tones. Highlights should not be drawn around, but lifted with your kneaded eraser. This will make them appear as if they are reflecting off of the top surface of the lips. On the closed mouth, a hard edge is created where the two lips come together. Do not draw this as one continual, even line. Close observation will show that this line varies in width and in tone. The "pit" of the mouth at the corners is essential to make the mouth seem as if it is sinking into the face, not just lying on top.

Graphing the Mouth

Here you can see that for a closed mouth, I have used a 1-inch graph. This is because on a closed mouth the shapes are not complex, and can easily be contained in the larger squares. Again, see everything as just shapes, and draw what you see in just one box at a time. Include the nose and the chin in your drawing. This will help prepare you for drawing the entire face. Note that the skin is not white, and should be drawn as a halftone.

Graphing a photo of an open mouth will give you practice with the teeth. I have used a ½-inch graph on this photo in order to draw the placement of the teeth accurately. The ½-inch graph gives you less room for error. Although the teeth are very white, there are shadows and bright highlights on them. A comparison of the tones between the teeth and the skin shows you just how much darker the skin is when compared to white. To capture the highlights on the lips, nose and teeth, lift them with your kneaded eraser.

For additional practice, go through your magazine references and draw as many mouths as you can. Try both male and female, in as many different poses as you can find.

Using a 1-inch graph is fine for drawing a closed mouth.

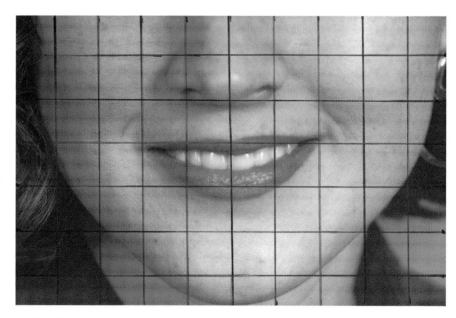

A ½-inch graph makes it easier to draw the teeth accurately.

Drawing Facial Hair

Now that you are becoming comfortable drawing the nose and mouth, you are ready to take on more of a challenge. This is a good time to try drawing a mouth with a mustache or beard, since in portrait drawing, many of your subjects will have them.

A mustache or beard has fullness and depth. It must be built up in layers to give it the fullness it needs in order to look real. This is also a good introduction to drawing hair, which we will cover in chapter eight.

There are many things to look for when drawing facial hair. Not only are the shapes important, but the coloration of the hair must be considered. Stop and look to see how the color of the hair looks next to the skin. Is it light against dark, or is the mustache darker than the skin? Also, does the entire upper lip show, or is it partially covered by the mustache? The pattern of hair growth, especially in the beard, is different and unique for each man. All of these factors—shape, fullness, coloration and growth pattern—must be carefully studied and accurately drawn in order to render a true likeness. Drawing generic-looking facial hair will make your portrait look cartoon-like.

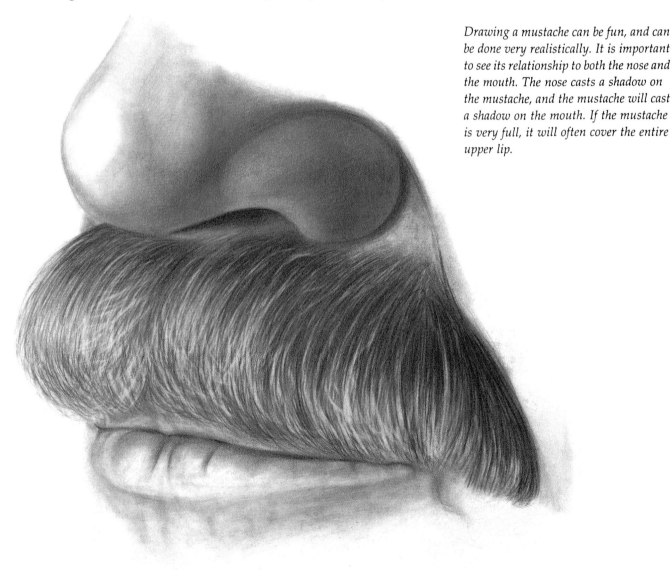

Drawing a mustache can be fun, and can be done very realistically. It is important to see its relationship to both the nose and the mouth. The nose casts a shadow on the mustache, and the mustache will cast a shadow on the mouth. If the mustache is very full, it will often cover the entire upper lip.

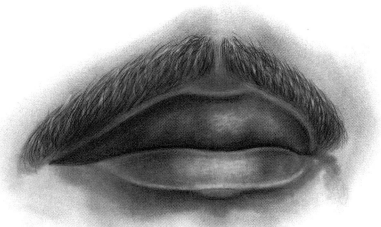

This mustache is very dark, short and somewhat coarse. Because it is short, the edge of the upper lip is showing. There is a rim of light above the lip that separates the lip from the mustache. Notice how the illusion of fullness is achieved by lifting out some light hair lines on top of the dark ones with a kneaded eraser.

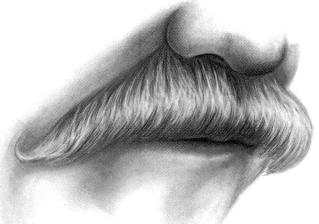

These lips are very subtle, and created more by tone and shadow. The mustache covers the upper lip and curves into it. The hairs of this mustache are quite long and smooth. The light reflecting off it gives it the roundness it needs, since it is very full.

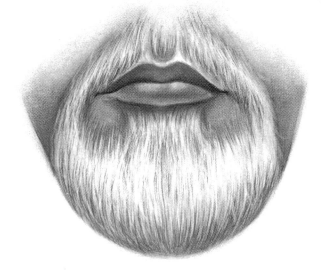

Often a mustache and beard will connect together on the face. The lips on this subject are also full and clearly seen, but unlike the first illustration, the facial hair is light against the skin instead of dark. The roundness of the beard is created with shadow, to look as if there is a chin underneath. Once again, the light hair lines have been picked out with the kneaded eraser.

Drawing Facial Hair Step by Step

It is important to build up the facial hair in layers, just like the hair actually grows, to keep it from looking flat, thin and unnatural. Remember that underneath the hair is the facial structure. You must study the shape and proportion of the upper lip and chin to avoid drawing a beard that looks pasted on.

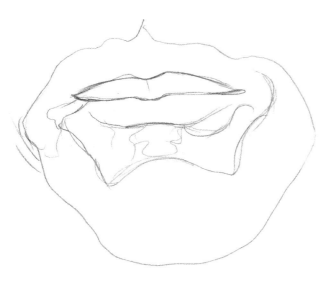

Step 1 LINE DRAWING
Begin drawing the beard and mustache by blocking in a line drawing of the entire, overall shape. Watch for the shapes or patterns of hair growth between the lips and beard.

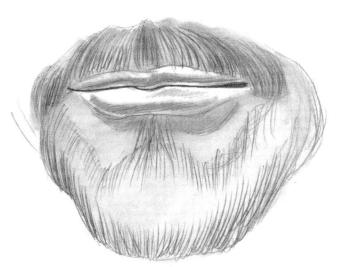

Step 2 TONES AND STROKES
Now begin to apply your dark areas, such as the shadow edges on the lips and the mustache hairs above the lip. Blend out the mustache. Apply tone to the skin area below the bottom lip and blend out. Begin to build the shape of the beard with quick strokes around the edges, and blend that out too. Everything at this point will be somewhat of a halftone, except the lips.

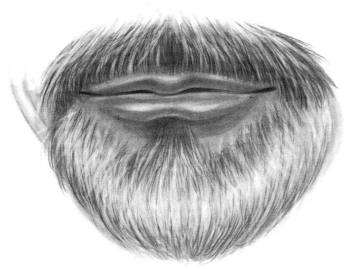

Step 3 LIGHTS AND DARKS
The halftones serve as a foundation for building up the depth and details. Darken the mustache and beard using quick, tapered pencil strokes. Lift out some light, highlighted hairs with the kneaded eraser. Keep applying lights and darks until you create the fullness you need, and the correct coloration. Finish your drawing by lifting some stray hairs that overlap the others.

Portrait of a Distinguished Gentleman

A man with a beard or mustache is a fine subject for a very distinguished-looking portrait, and this is an example of the realism you can achieve with the blended pencil technique. It is reminiscent of the portrait style of the "old masters," which used light and pose to give subjects a look of importance and dignity.

Notice how the upper lip is shadowed because it angles away from the light source. The lower lip is very subtle and blends into the white of the beard.

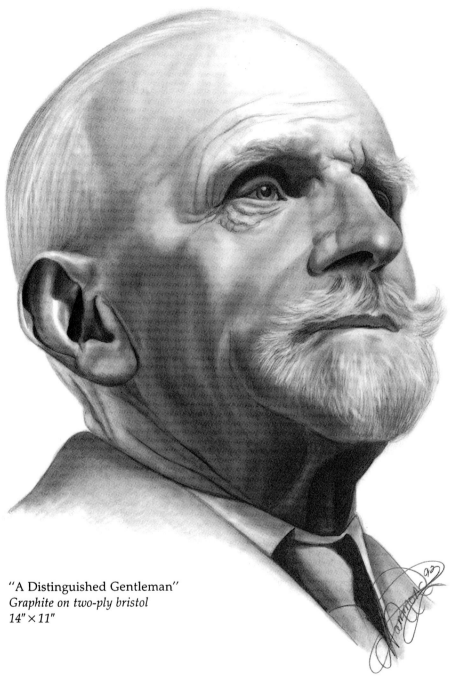

"A Distinguished Gentleman"
Graphite on two-ply bristol
14" × 11"

Important Points to Remember

1. Never outline the mouth.

2. The upper lip is always darker than the lower lip.

3. Check the angles that make up the lips to accurately draw the pose.

4. Look for the shadows on the teeth.

5. Teeth must be accurately drawn in size, shape and placement.

6. The gumline and the areas below the teeth will help define their shape and placement.

7. Men's lips are less defined than women's and are often created by shadows.

8. Use a ½-inch graph to help draw the placement of the teeth.

9. Mustaches and beards must be drawn in layers to achieve depth and fullness.

10. Practice!

11. Practice!

12. Practice!

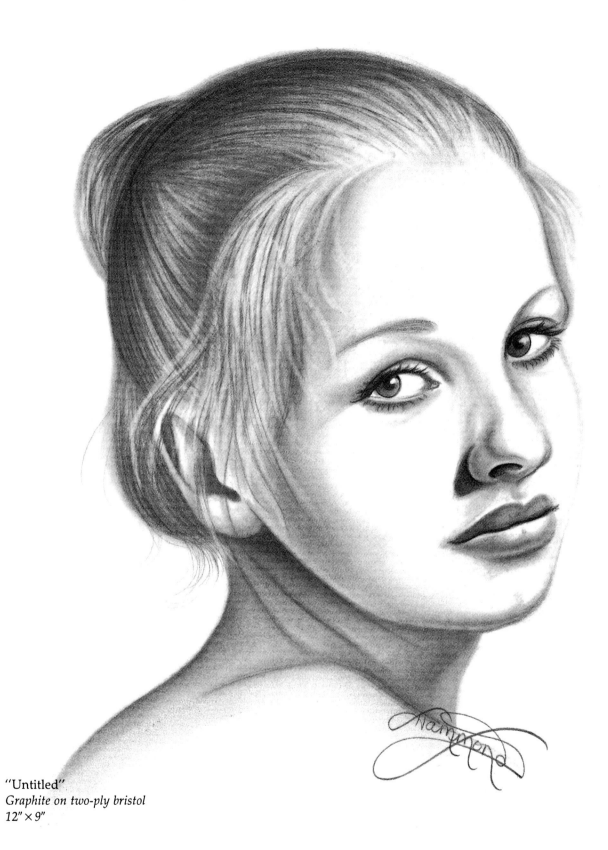

"Untitled"
Graphite on two-ply bristol
12" × 9"

Drawing the Ear

Drawing the ear can be confusing because the ear is made up of many interlocking shapes. This is where the Puzzle Piece Theory will help you—you'll see the ear as nothing more than shapes and forget that it is an ear.

Not only does the ear contain many different shapes, it has a variety of tones. Because of its curved, rounded surfaces, it has many shadow edges and areas of reflected light. Since the ear is not flat to the head, but projects outward, there will also be cast shadows. Add to these things the fact that you also have hair to deal with, and you can see how drawing the ear can become a bit of a challenge.

This is where you'll find out how well you see shapes, and how important the elements of shading really are. The good thing is that on an average portrait, you usually will not see the entire ear.

Look for Interlocking Shapes

Begin by studying the curves and shapes shown here. All of the five elements of shading are represented, from the deepest tone in the cast shadow to the white of the highlighted rim. Gradual blending of tones gives the rounded, three-dimensional look to the many folds and curves of the ear.

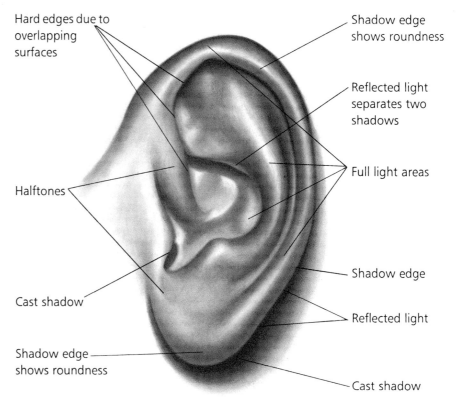

Hard edges due to overlapping surfaces

Shadow edge shows roundness

Reflected light separates two shadows

Full light areas

Halftones

Shadow edge

Cast shadow

Reflected light

Shadow edge shows roundness

Cast shadow

Graphing the Ear

Graphing the ear will help you see all of the interlocking shapes. By paying strict attention to the shapes inside one box at a time, the entire ear will take shape. Be sure to include the hair and the shadows surrounding the ear.

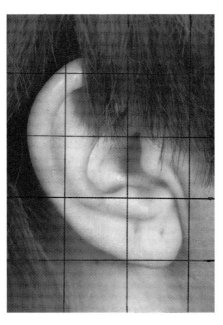

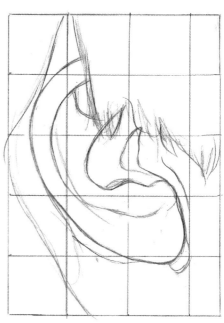

Graphing the ear will help you see its shapes.

Draw one box at a time. Include the hair and the shadows.

Drawing the Ear Step by Step

The ear, as you have probably already noticed, is very different from the rest of the features. Not only is the shape very unique, but the skin and texture are totally different. The ear is oilier, so it will have more of a shine to it. These bright highlight areas are important to its overall look. Because of the many areas of overlap, the darks can be very extreme. Be sure to study the shapes carefully, and see where there are "shapes within shapes."

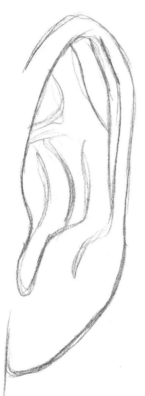

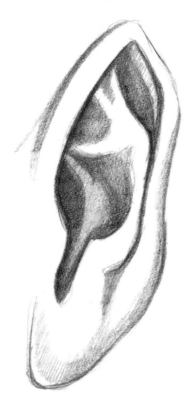

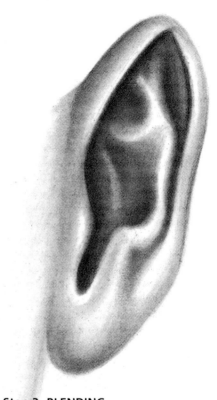

Step 1 ACCURATE LINE DRAWING
Begin with an accurate line drawing. Do not remove your graph and begin your shading unless you have double-checked your shapes for accuracy.

Step 2 PLACEMENT OF TONES
Fill in your dark areas and tones. Look for the hard edges that are created by overlapping surfaces. Keep your edges crisp, but be sure not to outline.

Step 3 BLENDING
Blend your tones from dark to light. Pull out your highlights with the kneaded eraser. Look for where edges are reflecting light. Remember, anything with an edge, a rim or a lip will reflect light.

Look for Contrasting Edges

It is very important to study the "edges" that are found on the ear. When the ear alone is drawn, as seen in the example below, there is no cast shadow below the earlobe. Because of this, the edge of the earlobe appears dark. The other two examples show how the ear creates a cast shadow on the neck. You can see that the edge of the earlobe appears light against the cast shadow, and the reflected light separates the edge of the lobe from the surface beneath. This is what makes the earlobe seem rounded and three-dimensional.

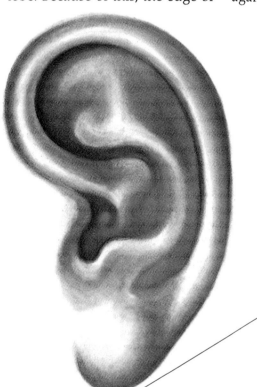

Contrasting edges

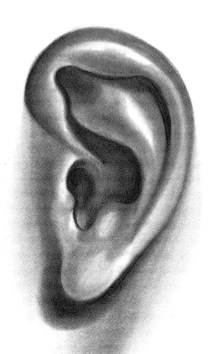

The cast shadow on the neck below the ear helps define and give dimension to the earlobe.

Personalizing the Ears

Rarely will the entire ear be seen in the average portrait. Jewelry and hair will often hide a great deal of it. It is important to practice these variations. And although ears are somewhat general in their anatomy, everyone's ears have their own characteristics, whether they be in the size or the shape. Often wrinkles and lines make them more realistic and personal. And look for differences in the earlobes—some are connected to the jawline while others are long and dangling.

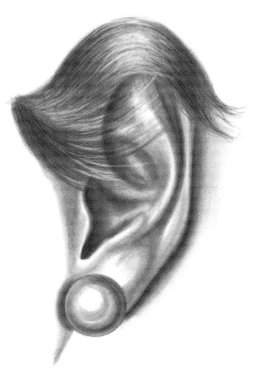

The hair, which will often come across the ear, should appear convincing. Fine hair lines can be lifted out with the eraser. The earring looks like an exaggerated version of the sphere exercise.

A front view of the ear will foreshorten the shapes that are found within it.

On this ear, only the bottom portion is showing. The cast shadow of the hair behind it helps create the roundness of the earlobe by emphasizing the reflected light.

Many people have creases in their earlobes, which is part of their unique appearance.

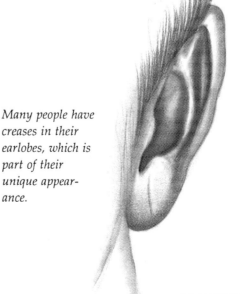

Placement of the Ear

Although the ears vary in size and shape from person to person, there are some general guidelines that will help you with their placement.

By studying the diagram below, you can see that the ear does not sit straight up and down on the side of the head, but is angled backwards. The top of the ear will line up with the base of the eyebrow and the bottom will line up with the base of the nose, with that distance being equal to that of the base of the nose to the chin (3 to 2 equals 2 to 1).

On a profile view, the ear is about halfway between the back of the head and the front of the facial plane (*not* the front of the nose) (6 to 5 equals 5 to 4). The corner of the jawline descends from the front of the ear.

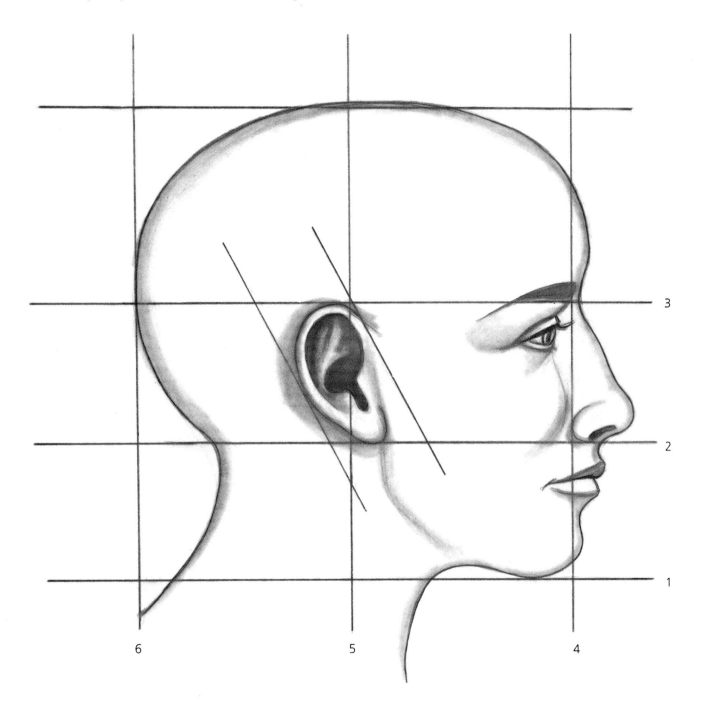

Important Points to Remember

1. Look at the ear as puzzle piece shapes.

2. Watch for highlights and reflected light.

3. Watch for hard edges where surfaces overlap.

4. Placing tone behind the ear will help create the shape.

5. Look for the cast shadow created by the ear on the neck.

6. Practice placing hair and jewelry on the ears.

7. Keep in mind the relationship of the ear to the other features.

8. The ear is not straight up and down. Remember the tilted angle.

9. Practice!

10. Practice!

11. Practice!

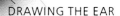

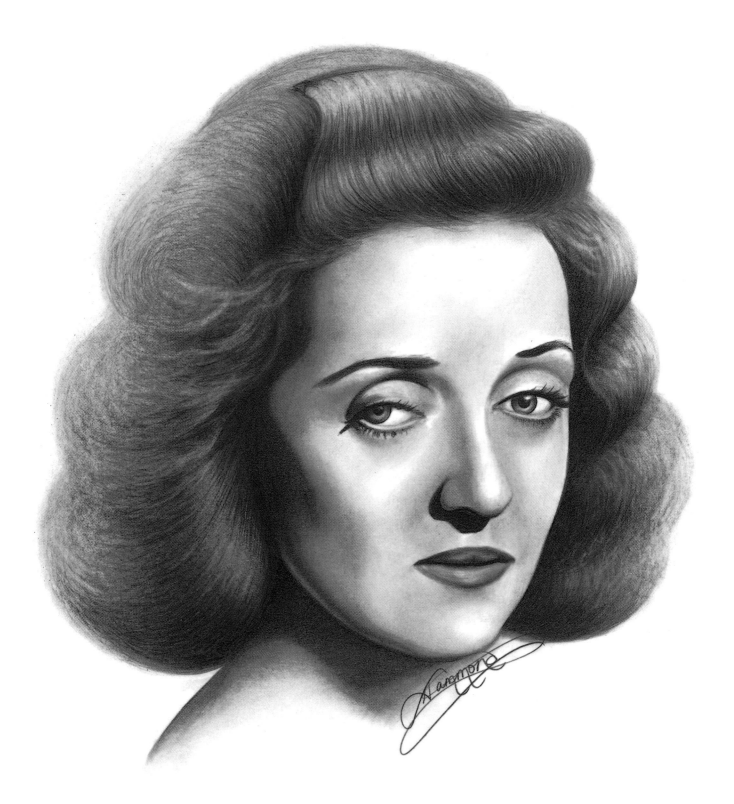

"Bette Davis"
Graphite on two-ply bristol
12" × 9"

Drawing the Eyes

The eyes have often been referred to as the "windows to the soul," since they convey so much emotion and personality. For that reason, I find them to be the most important aspect of a good portrait. That is also why I begin all of my portraits with the eyes, rendering them first. By doing so, I can capture the spirit of the person right away, and I will always know early on if I have missed the personality of the subject in my work.

When drawing a portrait, we must draw the eyes of the person we are looking at, rather than drawing generic eyes or eyes as we *think* they look. We must forget all preconceived images of the eyes, and draw only what we see in front of us. Everyone has special characteristics that we must capture, and this can be done only by drawing accurately.

By looking at a finished drawing of an eye, you can see the many details necessary to make it look realistic. It is important to note the smooth blending from dark to light, and the effective use of shadows on the white part of the eye. A very small portion of the white area is actually white. Most of it is really a combination of halftones.

The Structure of the Eye

We will begin by reviewing the structure of the eyeball and its placement in the face. You will notice that I said "in" the face. That is because the eyeball itself is quite large in comparison to what we actually see. It sits deep inside the bony structure of the face, with only a fraction of its surface actually showing beyond the eyelids.

By studying these illustrations, you can see just how large the eyeball really is. From the front, it looks very much like the spherical shape we practiced our shading on earlier. See how the elements of shading are seen in both of them, with the exception of the cast shadow below the sphere. The full light area appears as a bright reflection due to the wet, shiny surface of the eye.

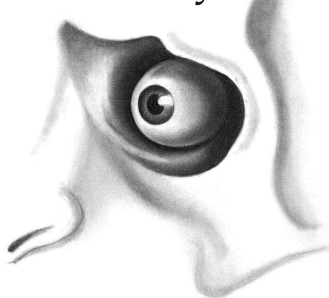

The eyeball sits "in" the face, deep inside the bony socket.

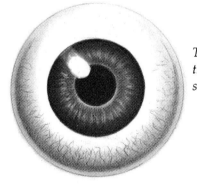

The elements of shading can be seen on the eyeball. Compare this with the sphere shown below.

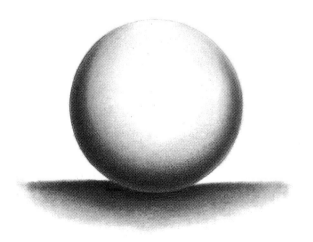

The Eye in Profile

From the side view, the eyeball has a bulge where the lens area protrudes. This gives it the appearance of an egg shape.

The illustration shows how the eyeball is placed behind the eyelids, and how deeply it sits in the face. See how the eyelid is stretched over the eyeball, and just how little of it we actually see? It is the curvature of the eyeball behind the lids that gives the eyelids their shape.

A good understanding of this shape now will help you later when we begin to draw eyes in various angles and positions. Often in a picture, especially of an unusual pose, shadows will hide the basic form from you. This general understanding will help you draw the shapes properly, even if you cannot see them well. It is this knowledge and understanding of the human form that earned the painters and artists of the past the title "masters."

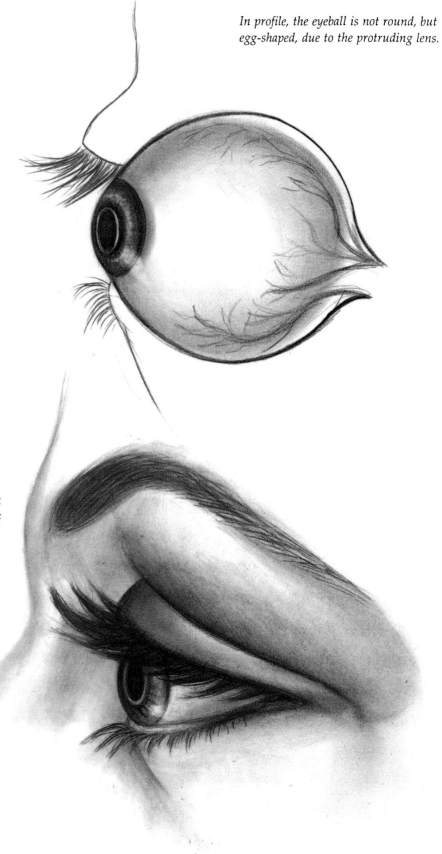

In profile, the eyeball is not round, but egg-shaped, due to the protruding lens.

Assembling the Shapes

The eye is made up of many different shapes. By applying the Puzzle Piece Theory and drawing each piece individually—carefully checking for size and shape—all of the pieces, or shapes, will fit together to form the eye. In the diagram, each shape has been numbered in the order in which it should be drawn.

Notice how the lashes, number nine on the diagram, have been treated as a solid mass. They create what is called a lash line, which is very dark and defines the curve of the upper lid. I do not put in individual lashes until the very last, when all of the blending has been completed.

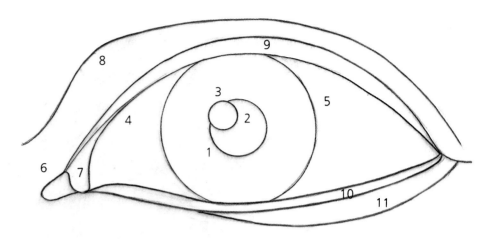

Draw each shape in the numbered order, starting with the iris and ending with the lower lid.

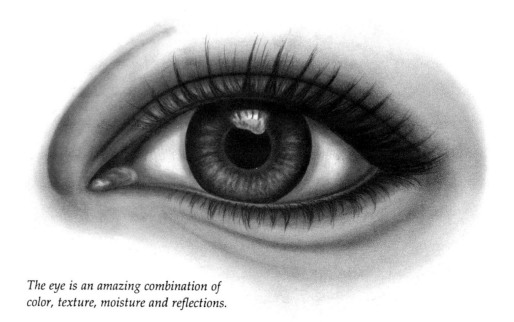

The eye is an amazing combination of color, texture, moisture and reflections.

Drawing the Iris

Not only do we need to concern ourselves with the shape of the eye, we need to deal with the color of the eye, or the iris. This is very important when capturing a likeness, since our eye color has a lot to do with our individual looks. For me, this is the most beautiful and challenging part of the eye. Even though we are drawing in pencil and dealing with nothing more than gray tones, we will be able to create the illusion of color just by the shades of gray we use in our drawing.

To judge the tones needed to duplicate eye color, picture a color photograph that has been re-printed in black and white. If you compared the two, each color in the picture would have a corresponding gray tone in the black-and-white print.

Eyes are much like a person's fingerprints, with no two exactly alike. Some irises will appear very smooth and pure in color, while others will have a great deal of patterning, almost like that of a kaleidoscope. The color of the eye will have a lot to do with the amount of pattern it has. A medium color such as green or deep blue will have the most design in it, with the highest degree of contrast and definition. A dark brown or pale blue eye will appear more smooth and even in tone.

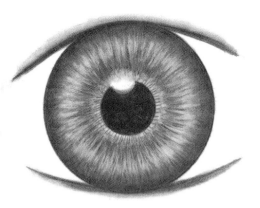

The depth of gray tone you use in the iris will give you the illusion of color.

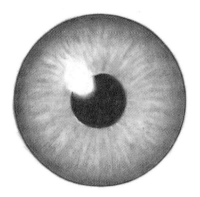

A blue eye.

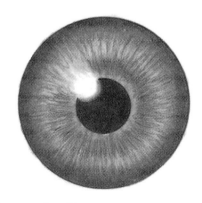

A green, deep blue or gray eye.

A brown eye.

Graphing and Drawing the Eye

Because the eye has many more details than the rest of the features, I have used the ½-inch graph to isolate the shapes more effectively. Start your drawing by referring to the numbered illustration on page 56, where each shape is numbered in the order in which it should be drawn.

1. Start with number one, the iris. Freehand it in for placement, and then trace around a "circle template" to make it perfectly round. The iris is one of the only perfect circles in nature, and should be drawn accordingly. If an iris is drawn out of round, it will look very odd.

2. Using your template again, draw in the pupil. This too is a perfect circle, and is *always* centered in the iris!

3. Place your catchlight, which is the flash reflecting off of the eye. This should always be placed half in the pupil and half in the iris. If your photo reference shows more than one, eliminate all but one.

4. Once these circular shapes have been placed, draw in the rest of the surrounding shapes. Let their placement inside the box graph guide you. Be sure that all of the shapes are correct before you erase your graph lines.

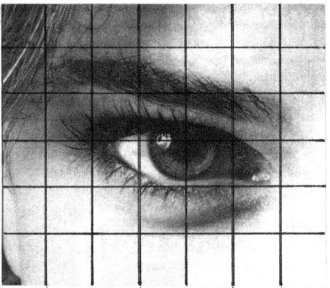

A ½-inch graph will help isolate the shapes and make them easier to draw.

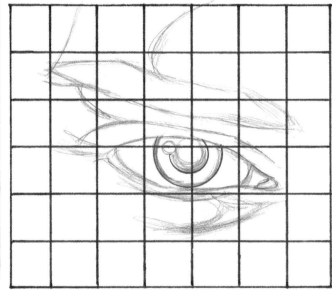

Be sure all of your shapes are accurate before removing your graph.

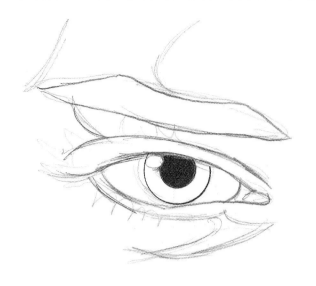

Step 1 ACCURATE LINE DRAWING

In this line drawing, notice how the shadow shape under the eye has been drawn in. Also, notice the area below the iris, or number ten on the diagram. This shows that the lower eyelid has thickness to it, and the bottom of the eye is not just to be outlined. Look at someone's eye right now, and you will see this detail. It is an extremely important element, and is almost always left out in beginners' drawings. If you go back to the beginning of this book and look at the students' early work, you will find their first attempts did not include the lower lid.

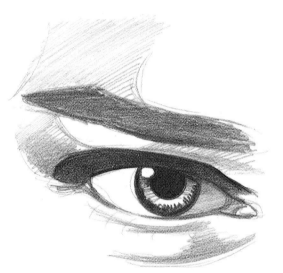

Step 2 PLACEMENT OF TONES

Now start to develop the patterns in the eye, and the shadows both around the eye and on the eyeball. Don't forget your catchlight. Fill in the eyebrow as a solid tone for now, and do the same with the lash line. Individual hairs come later.

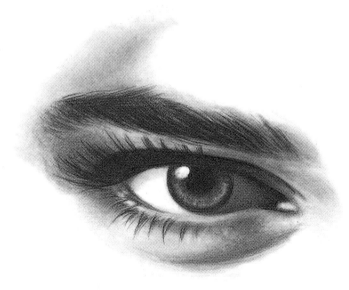

Step 3 BLENDING

Blending creates the roundness of the eye. All of the tones are very gradual and smooth. This is when the lashes are put in. Apply them as "clumps," not single little hairs. Use quick strokes so the line will taper at the end. The bottom lashes are much smaller and thinner, but are still in groups. The eyebrow is also made up of tapered pencil lines, following the growth of the hair. Unlike the lashes, they are gently blended out.

Shaping the Eyelids

At the beginning of this chapter, we discussed how the lens of the eye creates a bulge where it protrudes. This bulge can be seen when the light reflects off of the eyelid.

On these examples, notice how the shape of the eye is clearly evident beneath the eyelids. Whenever a surface protrudes farther than the rest of the object, the light will be stronger there. Practice drawing from these examples, keeping in mind the shape of the eyeball itself, and how it is creating the shape of the eyelid.

Take your graph and lay it over these illustrations for practice. Apply the five elements of shading, and practice judging your tones by referring to your five-box value scale. Go through magazine pictures and study the eyes in various poses. See if you can identify where the lens of the eye is catching light, and appearing as a highlight on the eyelid.

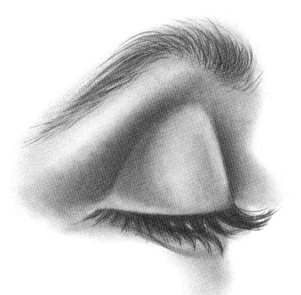

On this partially closed eye, the roundness of the eyeball can be clearly seen beneath the lid.

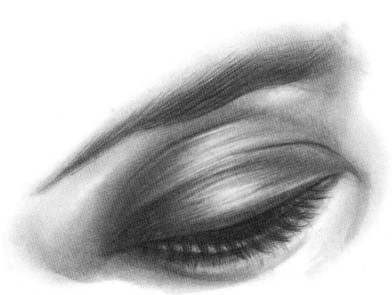

Where the lens of the eye stretches the eyelid, more light will be reflected.

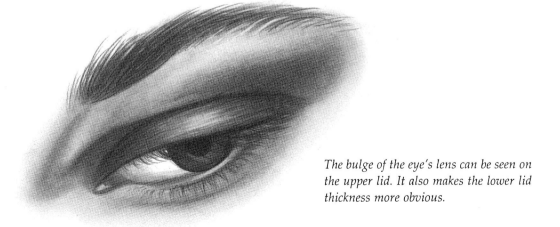

The bulge of the eye's lens can be seen on the upper lid. It also makes the lower lid thickness more obvious.

The Angle of the Eye

By looking at a side view of the eye, you can see how different our guidelines become. The iris, which will usually dominate the eye, can no longer be seen well, and the catchlight appears more like a streak than a spot or circle. The lens area where the eye bulges is almost clear, and allows light to pass through it. The over-all shape of the eyeball itself is very pronounced beneath the eyelids.

When the face is seen from the side, only one eye will be visible. The bridge of the nose will completely block the view of the eye on the other side. Notice how the eyebrow protrudes due to the brow bone.

The upper eyelid protrudes farther than the lower one, as can be seen in all three of these illustrations. There is approximately a 30-degree angle created by the way the eyeball sits inside the bony structure of the face. Always keep this angle in mind when drawing a profile.

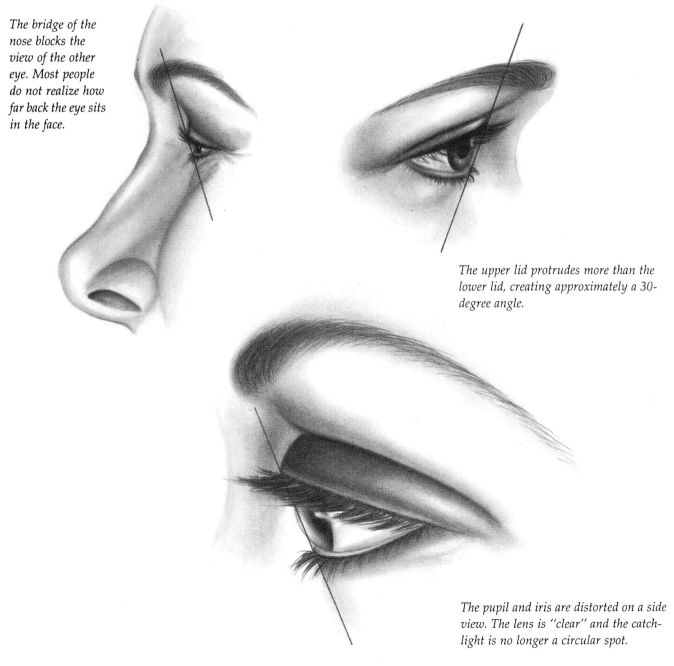

The bridge of the nose blocks the view of the other eye. Most people do not realize how far back the eye sits in the face.

The upper lid protrudes more than the lower lid, creating approximately a 30-degree angle.

The pupil and iris are distorted on a side view. The lens is "clear" and the catchlight is no longer a circular spot.

Drawing the Eyebrows Step by Step

There is another part of the eye that plays a very important role in a person's appearance: the eyebrows. They have as much to do with the overall look of the eyes as the eyes themselves, and have a lot to do with the expression you are trying to convey.

Eyebrows are easier to draw than you might think. But first,

you must analyze them and their placement on the face. Located above the eye, and following the bony structure that surrounds and protects the eye, the eyebrow is made up of many individual hairs. Never draw it just as a solid mass sitting on top of the skin. To make the eyebrow appear real, we must make the hairs and the

skin work together.

The examples here show both male and female eyebrows. See how different they are from one another? Men usually have thicker brows that are closer to the eye. Women's are usually more arched and defined.

FEMALE

MALE

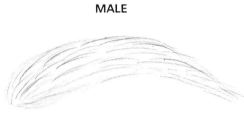

Step 1 SKETCH THE SHAPE
Start by giving yourself a light outline of the shape, and then study the direction of the hair growth. Create the illusion of hairs by applying quick pencil strokes with sharp outward wrist motions in the direction that the hair is growing. This will make the lines taper on the ends.

Step 2 APPLY STROKES AND BLEND
Start at the base of the brow where the hairs are thicker, applying strokes until they appear to overlap one another. Blend the whole thing out to give the illusion of a shadow created by the hairs on the skin. After blending, add more strokes to create density.

Step 3 BUILD UP LAYERS
Build up the layers until you get the volume and tone you need. With your eraser, pick out some highlights for contrast. This will give the illusion of layers with the top hairs reflecting light.

The Direction of Gaze

The eye and the eyebrow are affected by the way the head is tilted and the direction the eye is looking. The first example shows what happens when the head is tilted downward and the eye is looking up. The eyebrow seems much closer to the eye, and more shadows appear on the white of the eye. Also, the white of the eye is now evident under the iris. This happens only when the eye is looking up. Usually the lower lid cuts across the iris.

The second drawing shows what happens when the eye is looking to the side. The eyebrow runs into the bridge of the nose, with the inner corner of the eye being hidden. There is much more white of the eye showing on the left than on the right.

In both of the examples, see how much more visible the thickness of the lower lid is?

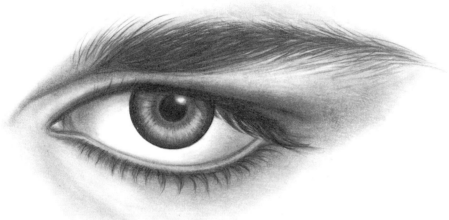

Notice how the white of the eye is showing below the iris.

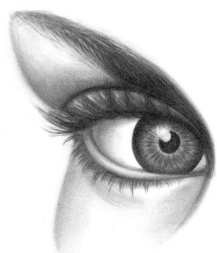

Drawing Men's Eyes

Men's eyes can seem much more complicated and intense. Due to the eyebrows usually being larger, the shadows and contrasts are more extreme. Watch for all of the little details and characteristics that are important to the subject's personality.

Here is a checklist to review as you practice drawing from this example.

1. Draw your iris and pupil with a template, so they will be perfect circles.
2. Include all eleven parts of the eye, as shown in the diagram on page 56.
3. Remember that there are shadows on the eyeball itself.
4. Do not forget the lower lid thickness.
5. Do not draw eyelashes one hair at a time. On this example, you barely see any lashes.
6. Keep your blending smooth and gradual to mimic the look of skin.

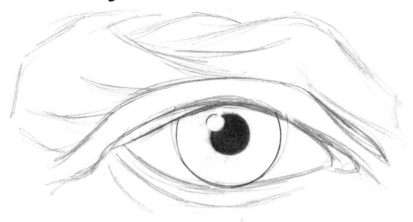

Step 1 ACCURATE LINE DRAWING

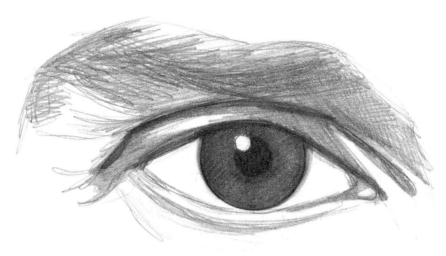

Step 2 APPLICATION OF TONES

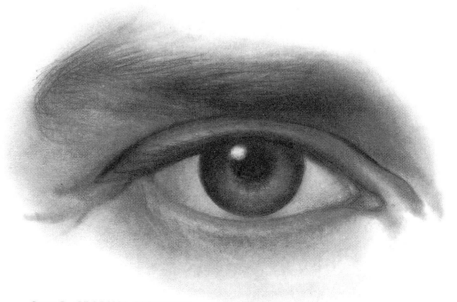

Step 3 GRADUAL BLENDING

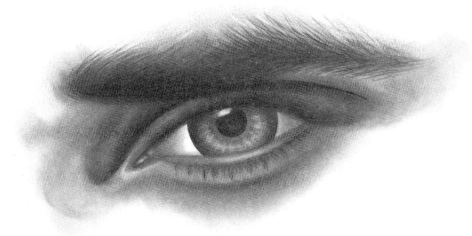

This eyebrow is very close to the eye; it even cuts across the upper eyelid.

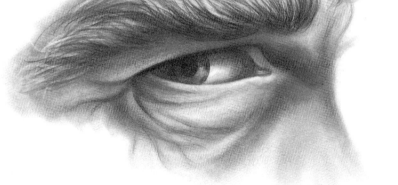

This deep-set eye looks very intense. Notice the use of shadows, and how the catchlights make the eye look wet. Usually in a proper, posed portrait I would have eliminated all but one of the catchlights I left these in for visual impact.

Eyebrows and wrinkles help describe a person's personality, mood and age.

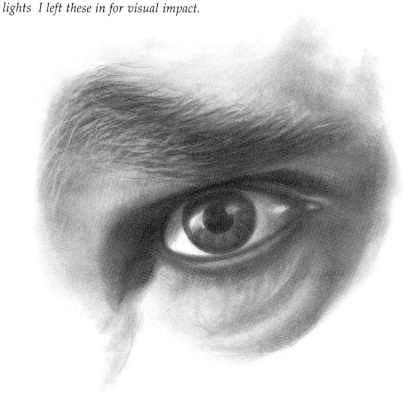

Placement of Eyes on the Face

The example below shows how the eyes work together with the nose in a straight-on view. If you measure the distance between the eyes across the bridge of the nose, from corner to corner, you will find it to be exactly one eye-width. By drawing a line down from the inside corner of the eye, you will find that the widest part of the nose is also one eye-width. Test this theory by going through your magazine pictures and mea-suring them. Be sure they are front views, with no tilt or turn. Go to a mirror, and see how these principles apply to your own face.

It should be noted that these guidelines are general, and apply mostly to Caucasian and Euro-pean races. The bone structures of other races will differ.

When drawing a face that is partially turned away from a straight-on view, it is critical to draw the angle of the eyes cor-rectly. By drawing a horizontal line under one eye at its lowest point, you can see how much higher one eye is than the other. By passing lines through both eyes from lid to lid, you can see just how acute the angle really is. Unfortunately, our minds make us want to draw eyes straight across. By drawing some guide-lines on your photo reference, you can overcome this tendency.

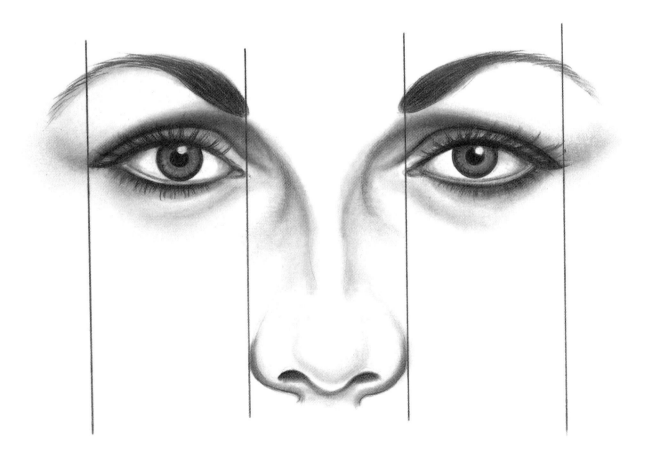

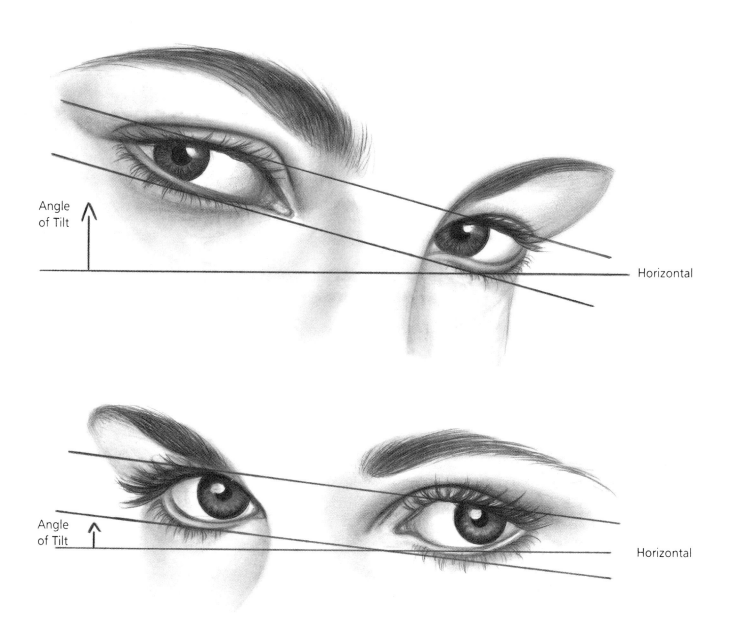

Angle
of Tilt

Horizontal

Angle
of Tilt

Horizontal

Although these eyes seem to be straight across, placing guidelines proves that the head is at a slight tilt, with the subject's left eye being lower.

Horizontal Ellipses

Up until this point we have been drawing mainly eyes that are looking straight at you. When this is the case the iris and pupil are perfect circles. But what happens to those circles when the eye looks away from you?

Think of the edge of a drinking glass. When viewed from above, the rim appears as a perfect circle, just like the iris. But when viewed from across the table, the full circle can no longer be seen. Our perspective changes, and we see a circle that has been tilted and condensed. This condensed, flattened circle is called an *ellipse*.

The same thing happens when the eye looks away from you, although the changes are much more subtle. Study the example below, and see how the perspective of the eye and iris change according to the direction the eye is looking.

HORIZONTAL ELLIPSES
A circle that changes from full to condensed or flattened is called an ellipse.

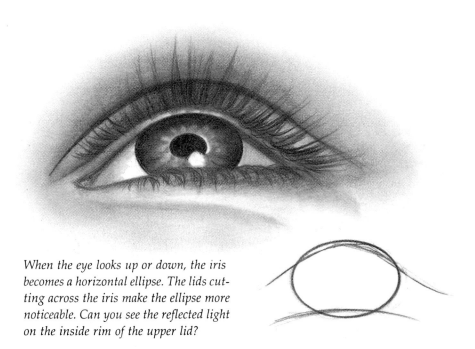

When the eye looks up or down, the iris becomes a horizontal ellipse. The lids cutting across the iris make the ellipse more noticeable. Can you see the reflected light on the inside rim of the upper lid?

Vertical Ellipses

Sometimes you will have to look closely to see vertical ellipses. They can be very subtle. These examples show what happens when the eye looks from side to side or when the head turns away from a straight-on view.

Notice that the pupil also turns into a vertical ellipse, but it still needs to be centered in the iris. To draw your ellipses correctly, you will need to use a template, just like the one you use for circles, only this one will have a variety of ellipses. Do not try to draw your iris and pupil freehand. It is too easy to get them uneven, and it will affect the quality of your work.

VERTICAL ELLIPSES

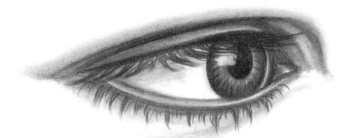

Even though the iris and pupil are now vertical ellipses, they still need to be centered with one another. See how the eyelids cut across the iris?

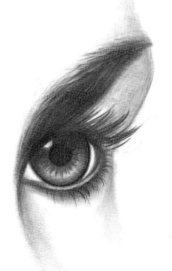

Although the iris of this eye appears to be a circle, it really is a very subtle vertical ellipse.

Children's Eyes

So far, we have been dealing only with adult eyes. In your portrait drawing days ahead of you, you will probably want to draw children, whether your own or someone else's. Children make wonderful subjects with their smooth features and cheerful expressions. When drawing a child's eye, you will find many differences, depending on the age of the child. The eye changes as a person grows from infancy to adulthood, just like the other facial features.

The overall shape of an infant's eye is very round, since the facial bones are not as pronounced at this age. Notice how big the iris appears, since it is full size at birth. It is smooth in color, with little speckling. The eyelashes have not developed much and do not show.

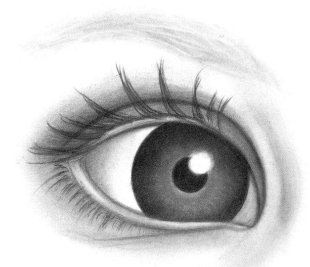

On a toddler, the lashes begin to fill in, as well as the eyebrow. Notice how light it appears. The coloration of the iris is still smooth, and the overall eye is still very round when compared to that of an adult.

As the child grows older, the bony structure begins to take shape around the eye. The patterns of the iris are beginning to develop, as well as the thickness of the eyebrow.

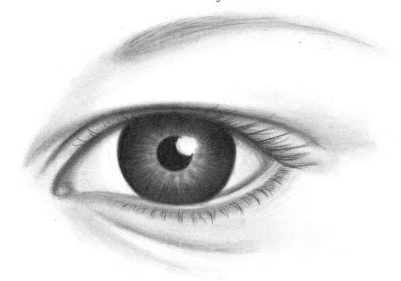

Expressive Eyes

So much expression can be seen in the eyes! Depending on how the facial muscles surrounding the eyes are working, a great many emotions can be expressed. Wide open eyes and raised eyebrows give the impression of surprise, fear or apprehension.

Tightly squeezed lids and the gathering of all the muscles toward the front of the forehead shows an intense individual. Whether it is physical pain, or mental anguish, all of the emotions can be seen in the eyes. The closed eyes make you feel calm and relaxed just looking at them.

Although you probably will not encounter this extreme of moods in portrait drawing, there may come a time when you will want to draw *character studies*. This gets you away from a posed portrait, and illustrates what a person is feeling and doing.

It's fun to collect as many different expressions as you can with your magazine pictures. Try to capture the mood of the subject just by drawing the eyes.

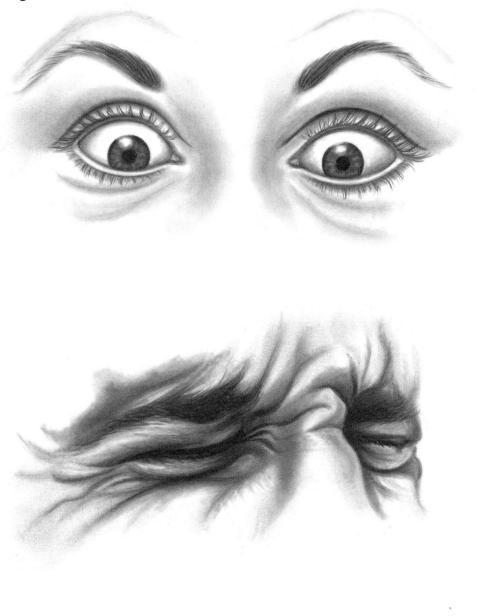

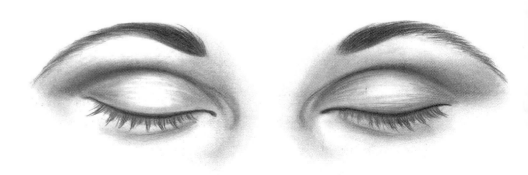

Graphing the Eyes

Here are two photo examples for you to work from. Both of these models have their own special qualities. Notice how the eyes of the first model are fairly light, with the eyelashes not very evident. The lower lid thickness is not as obvious, because the light lashes do not contrast with it. The eyebrows are fairly light and close to the eyes.

The second example shows how dark brown eyes look. It is hard to see which is iris and which is pupil. Also, the eyelashes are quite long and dark, which shows off the lower lid thickness.

Both of these photos have double catchlights in the eyes, due to the flash. Reduce this in your drawing to one in each eye. Make sure that they are half in the pupil and half in the iris, and in the same place in each eye.

This photograph will give you practice drawing the eyes in profile. Remember, the iris and the pupil become vertical ellipses when viewed from this angle. Use the graph lines to help you with the placement of the features.

The lighting in the photo at right makes the front of the face appear very light against the background. In order for those highlights to show up in your drawing, you will need to blend some tone into the background of your work. Notice that the nose appears light against dark, but the underneath part of the chin, which is in shadow, appears dark against light. It is this type of observation that will make you successful in portrait drawing and proficient in capturing realism.

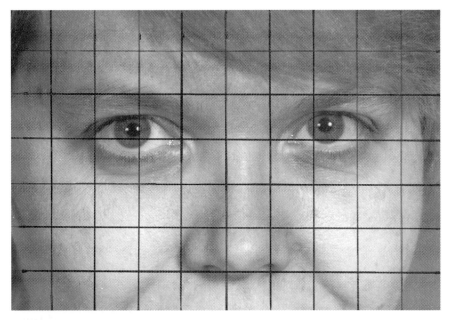

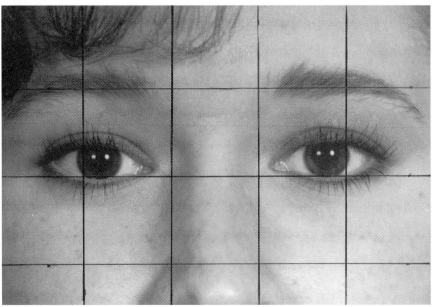

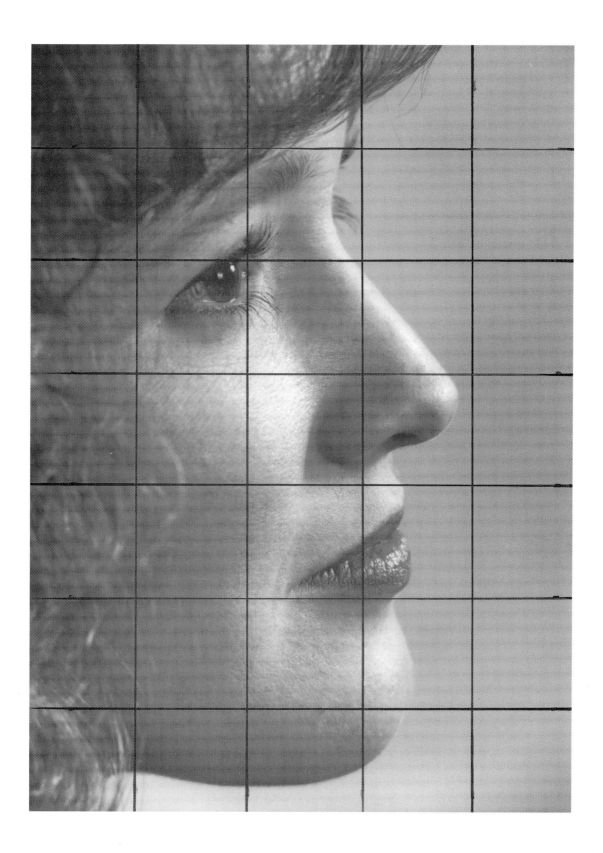

Drawing Eyeglasses

Although it would be much easier to never draw people with eyeglasses, that is not very realistic. You will find as you do more and more portraiture that a good percentage of your subjects wear glasses. So it is very important to learn to draw them, and draw them well. A good likeness of the person you are drawing will look ridiculous if the glasses he or she is wearing look like cartoons!

Look at how the eyeglasses can change the overall appearance of the eyes. They put the upper portion of the eyes in shadow, and they hide many of the shapes of the eyebrows and the bridge of the nose. Shadows are cast onto the face, both behind the glasses and below them. A close look at eyeglasses will reveal many areas of extreme darks and bright highlights, along with areas and edges that seem to disappear altogether.

One of the most important details is the tiny edge of light that is found around the inside edges of frames and lenses. It is this light that "lifts" the glass away from the face and gives the impression of space between the glasses and the skin. It is subtle, and does not show all the way around, but fades in and out. On the example below, it is most evident around the bottom edge of the glasses and in the upper corners where it stands out against the dark shadows.

When drawing eyeglasses, ask yourself, where is it light against dark, and dark against light? Forget what you *think* glasses look like, or you will end up outlining everything. Instead, take time to study the image closely, and try to imitate all of the little details you are seeing.

Wire rim glasses can be hard to draw because we have a tendency to make them much thicker than they really are. Be careful to watch your shapes for accuracy. Also, because they are metallic and reflect light, the rims seem dark in some areas, and light in others.

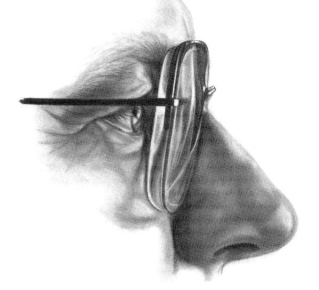

This profile study shows how complex the details can be, and how they affect the features of the face. Glasses are much easier to draw if you try to see them as just patterns of lights and darks, which will give the illusion of reflecting light and the shadows that are cast upon the face.

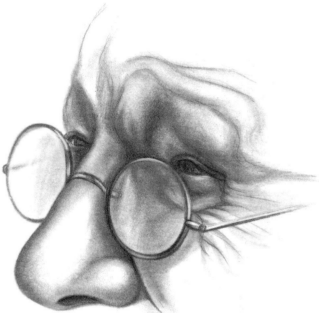

On this semi-profile the model's right lens appears light and a little foggy, while the lens on his left is darker due to the skin behind it.

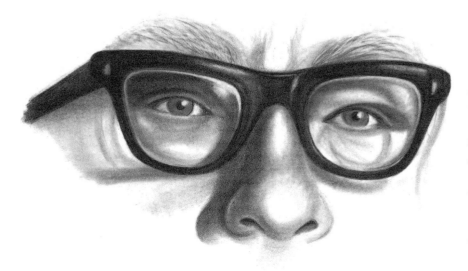

The frames of the glasses must be studied carefully for their shapes and where they reflect highlights. Notice that on these extremely dark frames the ridge of light that appears below the inside edge of the glasses. This small detail is what keeps the glasses looking as if there is some space between them and the face. Look at the shadows they cast onto the face, below the eye on the left, and through the eye on the right.

A Finished Portrait

This is a wonderful example of someone drawn with their glasses on. The artist took great care with the glasses to maintain the realism. By capturing the shadows that are cast onto the face, the artist clearly illustrates the relationship of the eyeglasses to the face.

The rims actually look shiny due to the proper use of highlights, and the lens areas appear real because of the edge of white that separates them from the face.

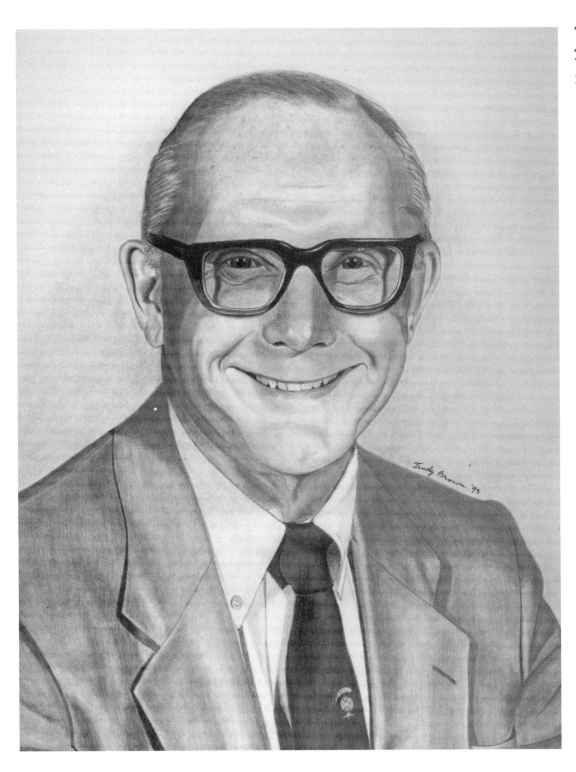

"Brother Ray"
Artwork by
Trudy Brown
14" × 11"

Important Points to Remember

1. The eyeball sits "in" the face.

2. There is one eye-width between the eyes.

3. Eyebrows and eyelashes should first be seen as an overall shape, with the individual hairs drawn in last.

4. The iris and pupil in the eyes are nature's perfect circles.

5. The perfect circles of the iris and pupil will turn into ellipses when the eye direction changes in any way from a straight-on view.

6. Always draw the iris and pupil with a circle template or an ellipse template for accuracy.

7. On a profile, the upper eyelid thrust is about a 30-degree angle.

8. Always look for the lower lid thickness.

9. Always reduce the catchlights to one per eye, and place them half in the pupil, half in the iris.

10. If the head is tilted, don't accidently straighten up the eyes. Be sure to have your angles accurate.

11. Eyeglasses should be seen as light and dark patterns.

12. Watch for shadows that are created by the glasses.

13. Look for the rim of light that separates the glasses from the face.

14. Practice!

15. Practice!

16. Practice!

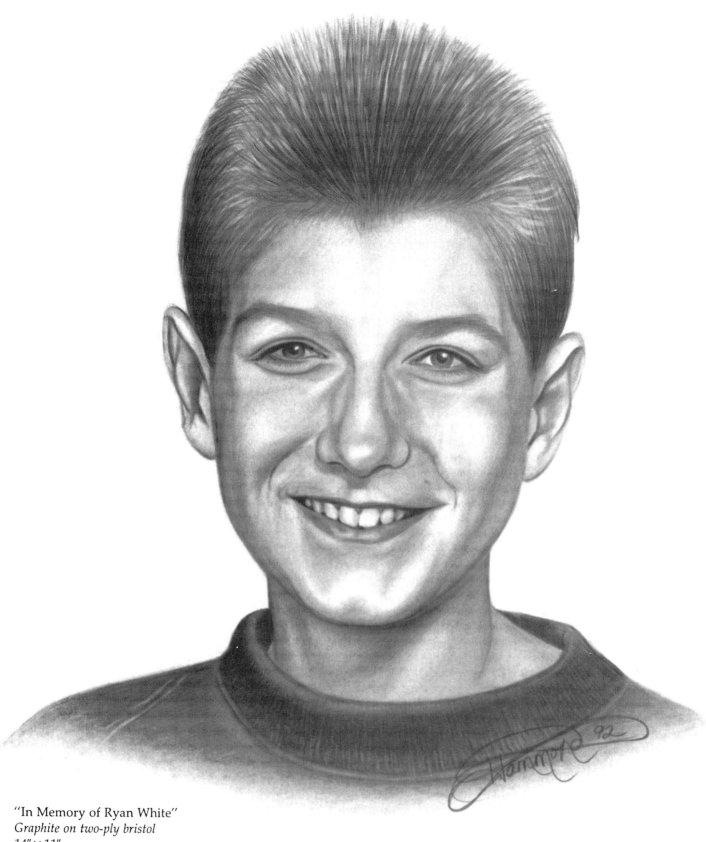

"In Memory of Ryan White"
Graphite on two-ply bristol
14" × 11"
Collection of Jeanne White Ginder

Putting It All Together

Now that we have practiced and explored each individual feature, it's time to tackle the entire face. Creating a likeness of someone requires time and patience, and the ability to tie all of the individual features together effectively, to see the face as a whole. A well-drawn portrait is one that captures and holds your subject's personality, and is well worth the time and effort invested.

Although the eyes were the last feature we studied, they will now become the first area to be rendered. The eyes become your focal point. Here is where your subject's personality will be revealed, and they will lead you, the artist, to the correct size and placement of all the other features.

As you progress through the step-by-step demonstrations in this chapter, refer back to the earlier chapters, refreshing your memory about the small details of each feature as you go.

Don't worry about the hair at this time. It will be covered in depth in the next chapter, and you can come back and finish your work later. Right now, concentrate just on the face. Take your time, practice, and do it well.

Correct Placement and Proportion

In these illustrations, you can see that the face and head can be divided into equal sections. If you look at line numbers one, two and three, you will see that line two marks the halfway point on the head—from the top of the skull to the bottom of the chin. Students are often surprised to see the eyes as the midway point, and want to place the eyes too high. There is the same amount of distance between the top of the head and the eyes as there is from the eyes to the chin.

Now look at line numbers one, four, and five. You will see that line four is the halfway point. There is the same amount of distance between the eyes and the base of the nose as there is from the base of the nose to the chin. You can also see how the ears line up between lines five and four.

The dotted vertical lines show the relationship of the eyes to the nose, mouth and chin.

Now study the profile at right. The vertical line through the ear represents the halfway point to the thickness of the head. There is the same amount of distance between the back of the head and the ear as there is between the ear and the front of the cheek bone.

The vertical line in front of the eye shows that even in a profile, the middle of the eye lines up with the corner of the mouth. The angled lines show the outward thrusts of the browbone and the upper lip.

The back of the head is really much shorter from top to bottom than the front. If you draw a line back from the nose and the ear, that is where the base of the skull meets the neck. The neck is not vertical, but tilts forward.

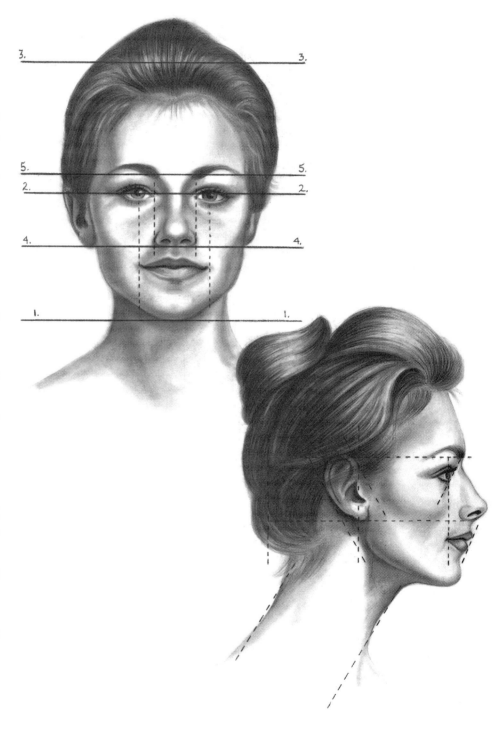

Graphing the Face

Now let's try graphing the entire face. In this photo reference, you can see that because the model's head is turned to her right, the head is tilted very slightly. Compare the angles of the eyes, nose and mouth to the horizontal graph lines.

As you practice drawing from this graph, refer often to the placement and proportion lines on the facing page.

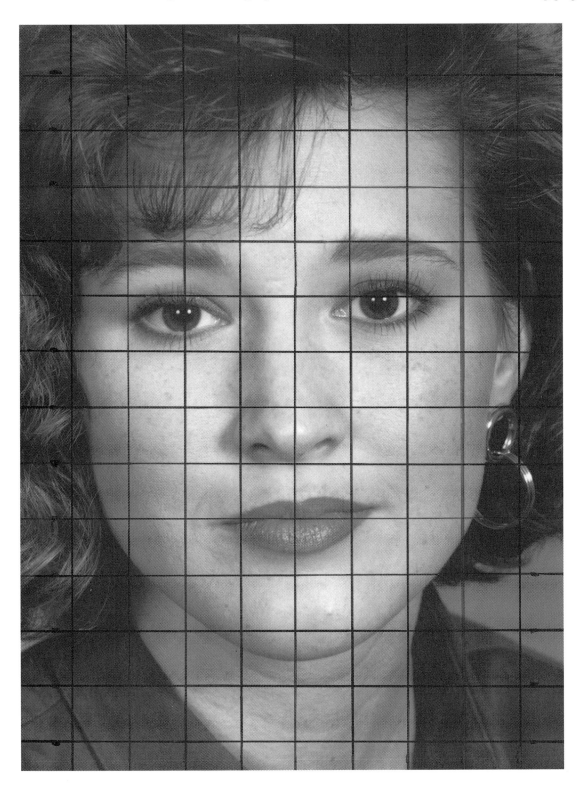

Working From a Photograph

Your artwork will be only as good as the photo reference you work from, so be sure to pick one that you can see clearly and that's large enough so you can see the features and their details. I think the face in your photo should be at least 3 inches high at the very minimum.

Choose a picture that has good contrasts of light and dark for a more interesting portrait. This photo interested me because the left side of her face is so much lighter. I think contrasts make a drawing look more artistic. I also liked the smoothness of the tones. The tones of this photo are not really extreme, and give it a muted, soft look—perfect for a little girl.

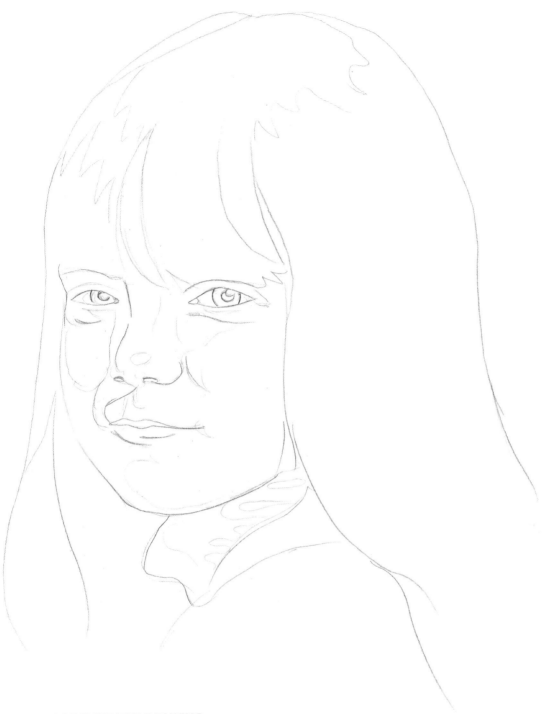

Step 1 ACCURATE LINE DRAWING
*Begin with an accurate line drawing.
This can be achieved by using your graph
over the photo. Include the features, the
shadows and the highlights. All of these
should be drawn in as* shapes. *Do not go
on to the next stage until everything is
accurate!*

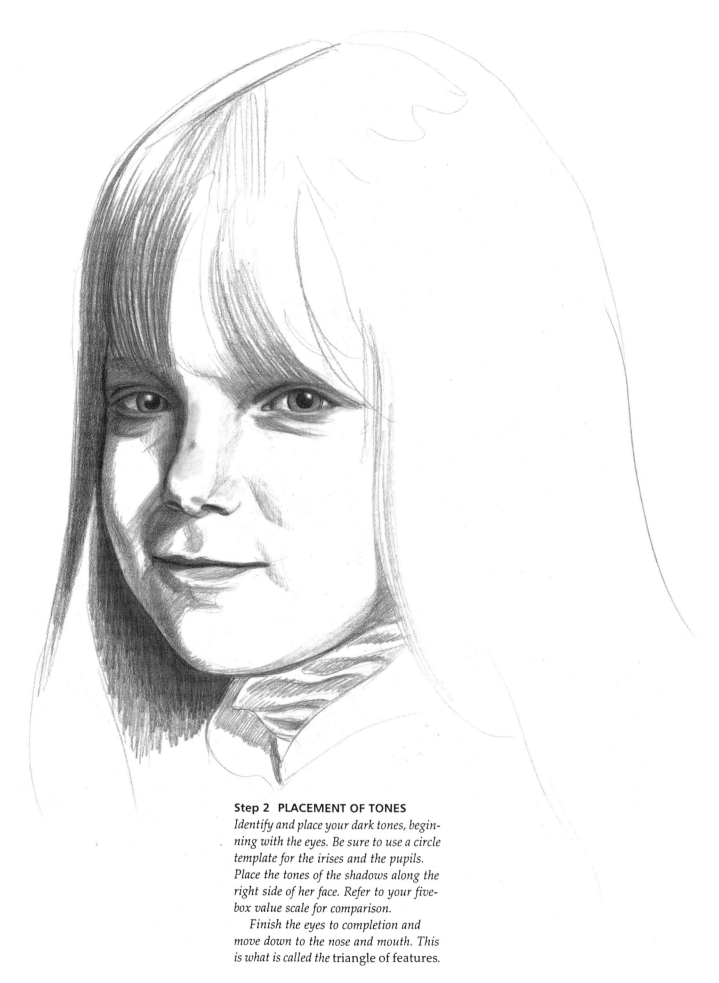

Step 2 PLACEMENT OF TONES

Identify and place your dark tones, beginning with the eyes. Be sure to use a circle template for the irises and the pupils. Place the tones of the shadows along the right side of her face. Refer to your five-box value scale for comparison.

Finish the eyes to completion and move down to the nose and mouth. This is what is called the triangle of features.

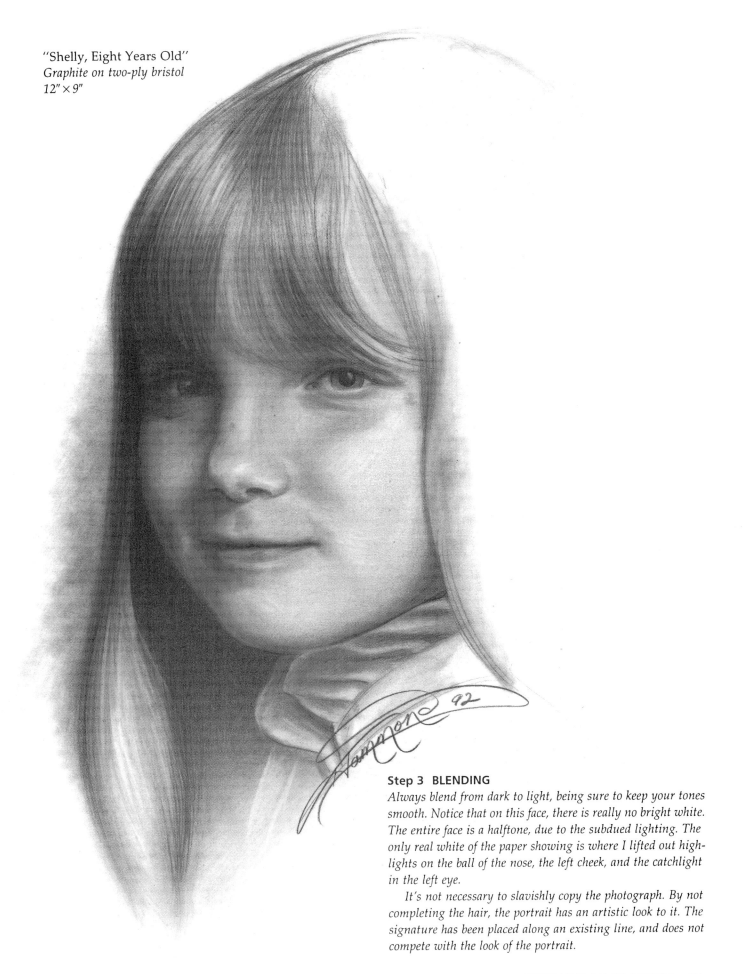

"Shelly, Eight Years Old"
Graphite on two-ply bristol
12" × 9"

Step 3 BLENDING

Always blend from dark to light, being sure to keep your tones smooth. Notice that on this face, there is really no bright white. The entire face is a halftone, due to the subdued lighting. The only real white of the paper showing is where I lifted out highlights on the ball of the nose, the left cheek, and the catchlight in the left eye.

It's not necessary to slavishly copy the photograph. By not completing the hair, the portrait has an artistic look to it. The signature has been placed along an existing line, and does not compete with the look of the portrait.

Drawing the Face

Here's another example of a complete portrait, in step-by-step form. Although this photo has stronger contrasts, follow the same procedure you did for the previous portrait drawing.

Be sure that your line drawing is extremely accurate. To get your outline, once again use your graph as a guide. Be sure to apply your graph lines on your paper very, very lightly, so they can be erased with ease, and not leave a ghost behind.

When drawing a portrait, keep the image of the person smaller than life-size. A larger version confuses the viewer and makes it look like you are too close to the subject. Place the drawing closer to the top of the page, with more empty space on the bottom. This maintains balance on the page, and keeps the subject matter from looking like it will slide off the bottom. Two inches of space on the top, with three or four on the bottom, will help balance your portrait.

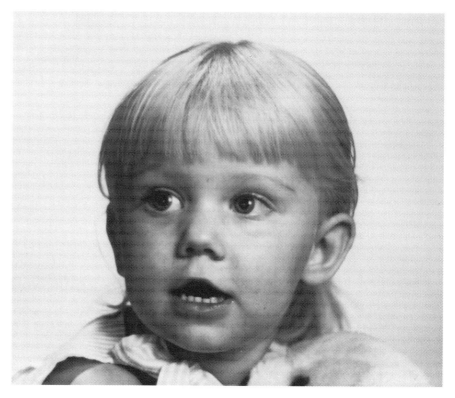

Step 1 ACCURATE LINE DRAWING
Look closely at this line drawing and you'll see where I've lightly penciled in guidelines for light and shadow areas. Compare these to the finished portrait on page 88.

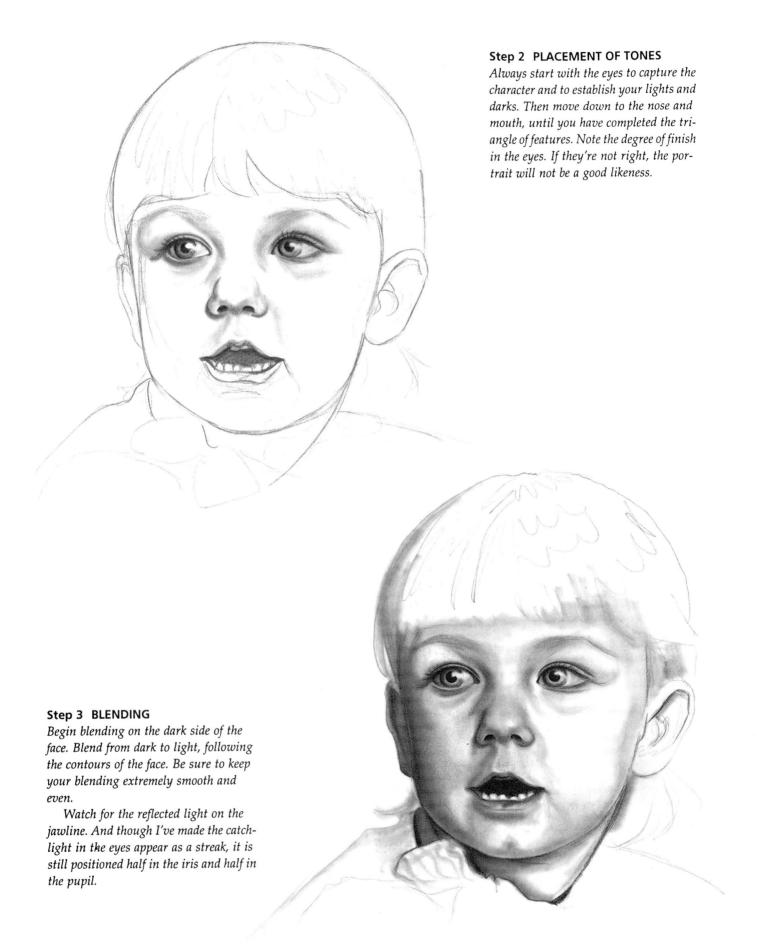

Step 2 PLACEMENT OF TONES

Always start with the eyes to capture the character and to establish your lights and darks. Then move down to the nose and mouth, until you have completed the triangle of features. Note the degree of finish in the eyes. If they're not right, the portrait will not be a good likeness.

Step 3 BLENDING

Begin blending on the dark side of the face. Blend from dark to light, following the contours of the face. Be sure to keep your blending extremely smooth and even.

Watch for the reflected light on the jawline. And though I've made the catchlight in the eyes appear as a streak, it is still positioned half in the iris and half in the pupil.

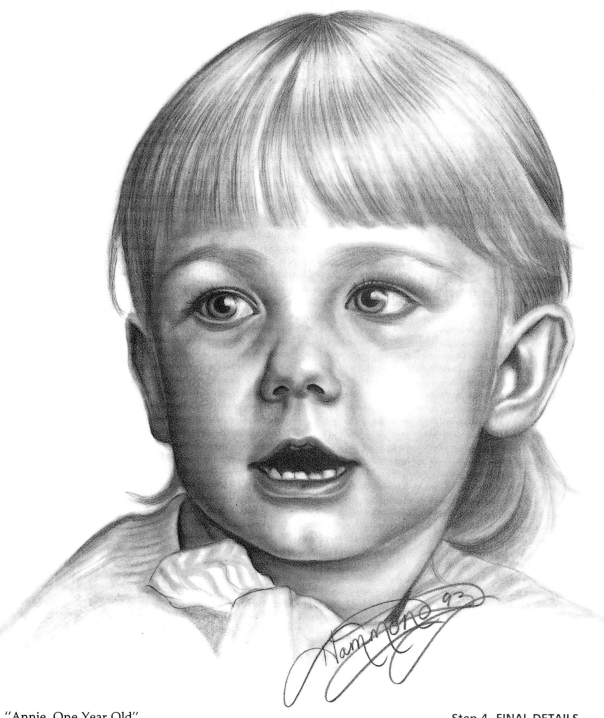

"Annie, One Year Old"
Graphite on two-ply bristol
12" × 9"

Step 4 FINAL DETAILS

Finish rendering the facial tones, the neck and the ears. For now, just do the best you can on the hair and the collar. We'll be studying hair and clothing in the next two chapters, so you can come back later and finish this portrait.

Important Points to Remember

1. Study the facial diagrams and memorize the general placement of the features. Remember the size relationships and measurements, and how the head and face can be divided into equal distances.

2. Work from a photo that is large enough so you can see the details clearly.

3. Start your portraits with an accurate line drawing.

4. Begin your rendering with the eyes and work them to completion before moving on to the other features. Move down to the nose and mouth, which is called the triangle of features. Then continue with the dark side of the face.

5. Make an artistic statement; do not merely reproduce the photo.

6. Practice!

7. Practice!

8. Practice!

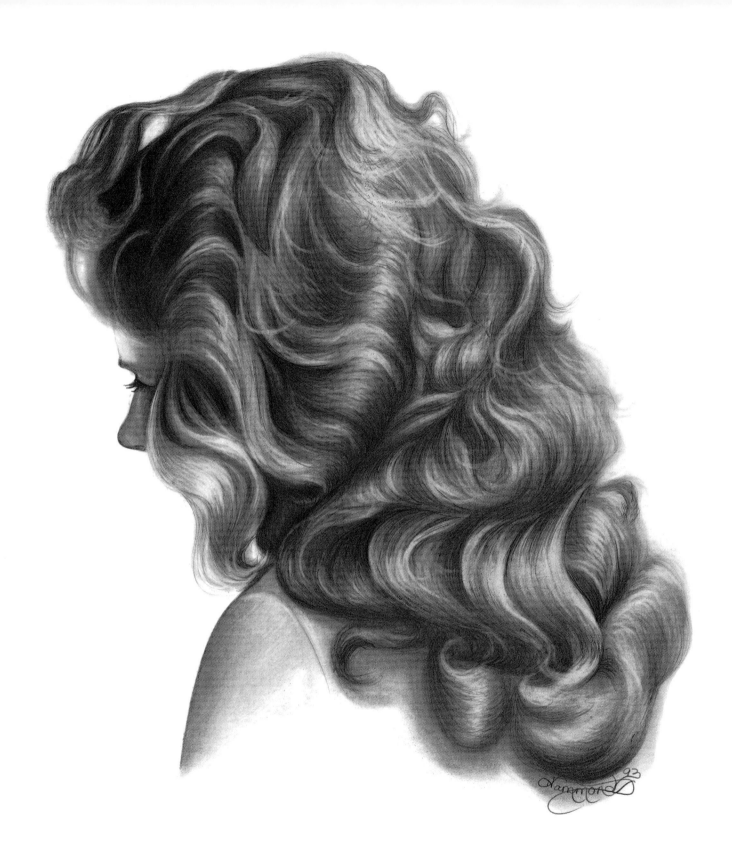

How to Draw Hair

O f all the features we've studied so far, the hair will require the most patience from you. It's not that the hair is necessarily that much harder, it just demands a lot more time to make it look real. The time required to draw the hair convincingly can sometimes be three to four times the amount it took to draw the entire face. Because the face is the focal point, we have a tendency to think of the hair as the last step, the quick final touch before the portrait is done. It may be one of the final steps, but it is hardly quick.

In the following pages, I have tried to give you a sampling of as many hair types and styles as possible. By practicing with these examples, you should be able to handle any hairstyle that will come your way. A good source of practice material can be found in hairstyling magazines. Their illustrations are wonderful for practicing the face and hair, especially because they are printed in black and white.

Do not let the full head of hair at left intimidate you. By following the three-step process, and devoting the time required, you will find that drawing hair can be a fun, rewarding challenge!

Drawing the Hair Step by Step

Like anything else, we should begin the hair with a line drawing. Look at the hair first as a solid shape, drawing its outside dimensions. The details of the hair will be built up slowly in layers.

Start applying the dark tones of the hair by laying in tone in the direction the hair is growing. Don't try to imitate hair strands with pencil lines at this stage. Just concentrate on filling in, and establishing the light and dark patterns.

Once the darks have been placed, blend them out to a half-tone. Reapply your darks by drawing the darks *into* the light area. On this example, you will draw from the bangs into the light area, and from the base of the ponytail *up* into the light. This light area, which follows the round contour of the head, is called the *band of light*.

Now, pull the light area into the dark with the sharpened point of your kneaded eraser, much as we did with the eyebrows and facial hair. Repeat the three-step process of applying the darks, blending the tones into one another, and picking out the highlights until the volume builds up and gives you the fullness that you need. *Don't stop too soon!* It will take a while to create the right balance.

Curly or wavy hair is done very much the same way as straight hair. The difference is that each curl or wave has its own set of lights and darks that must be drawn independently, and then blended into the others.

Never try to create the light areas of the hair by leaving the white of the paper showing and drawing around it. The highlights on the hair are actually the light reflecting off of the top, outside layers of the hair. If you just leave these layers out, it looks as

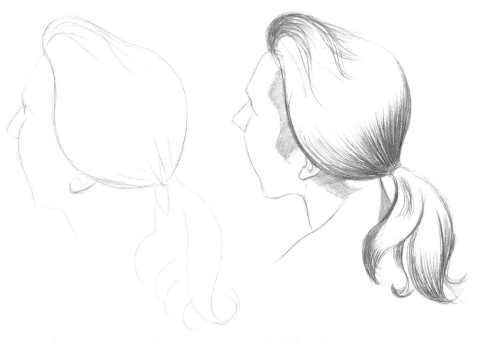

Step 1 DRAW THE SHAPE
Draw the hair as a solid, overall shape in your line drawing.

Step 2 ADD TONE
Draw your dark areas into *the light areas to create the band of light. Blend it out to a smooth tone.*

Step 3 BLEND AND LIFT HIGHLIGHTS
Reapply the darks, blend again, and lift the highlight areas with your eraser. Build the hair up in layers until you are satisfied. Let some of the pencil lines resemble hair strands on top of the blending. With your tortillon, gently soften the outside edges of the hair, all the way around, to keep it from looking hard.

if you are seeing *through* the hair. You must lay in your tone, blend everything out, and *lift* the highlights out with the eraser. This keeps the light on the outside layers where it belongs and softens the pencil lines, creating a gradual transition from dark to light.

When lifting your highlights, you can use your typewriter eraser for extremely light areas, but then soften it with your kneaded eraser. The typewriter eraser tends to leave sharp edges.

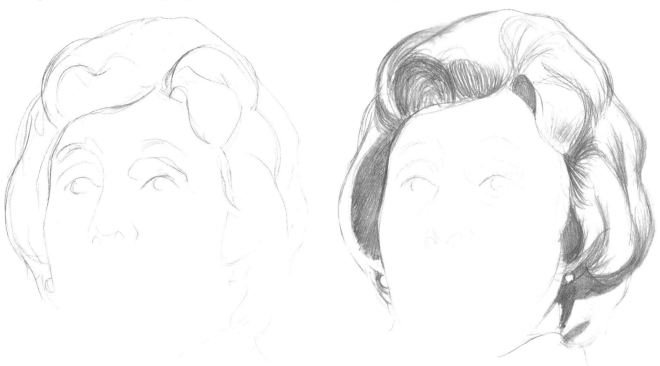

Step 1 DRAW THE SHAPE
Start with your basic outline, showing the overall shape and direction of individual curves and curls.

Step 2 ADD TONE
Apply the dark tones. Squint your eyes when looking at your photo reference to see the light and dark patterns created by the hair layers and curls. Apply the tones, going in the same direction of the hair.

Step 3 BLEND AND LIFT HIGHLIGHTS
Blend out the mass, redefine your darks, and pull out the highlight areas with your eraser. Watch how the lights and darks merge on each individual curl or wave. Keep building up tones to create the necessary volume. Finally, soften the outside edges with your tortillon.

Drawing Men's Hair

Men's hair is usually not as difficult as women's since it is so much shorter, but it is still important to show the thickness of it. The softness will be created by the blending, and the layers will be created by the highlights that are lifted with the erasers.

Watch how the hair creates shadows on the forehead and face. This makes it look as if there is some space between the hair and the skin. Soften the shadows under the hair so the hair and skin work together. When rendering the face it is important to complete the tones of the forehead and allow the hair to come over it. If the forehead is left white underneath, it will not look real.

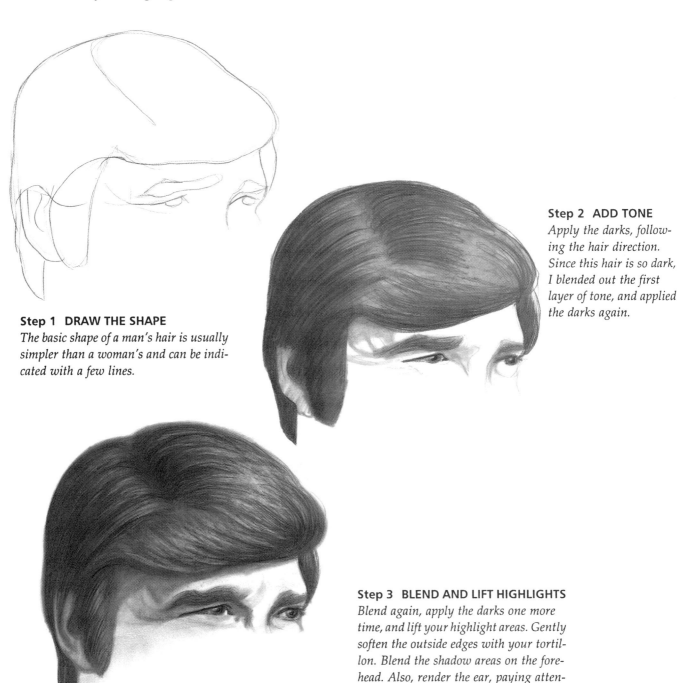

Step 1 DRAW THE SHAPE
The basic shape of a man's hair is usually simpler than a woman's and can be indicated with a few lines.

Step 2 ADD TONE
Apply the darks, following the hair direction. Since this hair is so dark, I blended out the first layer of tone, and applied the darks again.

Step 3 BLEND AND LIFT HIGHLIGHTS
Blend again, apply the darks one more time, and lift your highlight areas. Gently soften the outside edges with your tortillon. Blend the shadow areas on the forehead. Also, render the ear, paying attention to the way the hair goes over it, causing shadow there too.

Drawing an Ethnic Hairstyle

Drawing hair styled in an Afro is really a lot easier than you may think. The same rules apply to it as to the other hair types. The soft, full look is created by the same principles of lights and darks, with blending to soften it, and highlights to show volume.

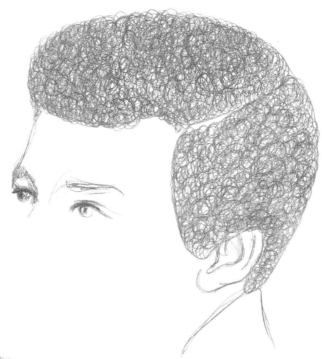

Step 1 DRAW THE SHAPE
Begin with the line drawing that gives you the basic shape to build on. Fill in the shape with small, tight circular pencil marks. This will give you some fullness.

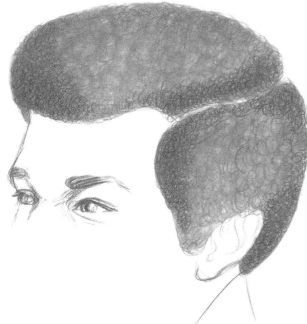

Step 2 ADD TONE
Blend the hair out, using the same circular motion used to apply the pencil marks. Darken the areas around the part of the hair and in front where the shadows are. Blend this out again.

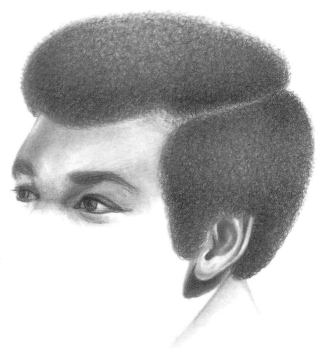

Step 3 BLEND AND LIFT HIGHLIGHTS
Reapply the dark areas with even tighter circles than before. Soften it a little bit with your tortillon, and begin to lift some highlights using a dabbing motion with the sharpened point of your kneaded eraser. Repeat this process until the hair reaches the fullness and softness needed to make it appear real. Once again, be sure the outside edge is soft, and apply the shadows on the forehead.

Drawing Various Hairstyles and Hair Color

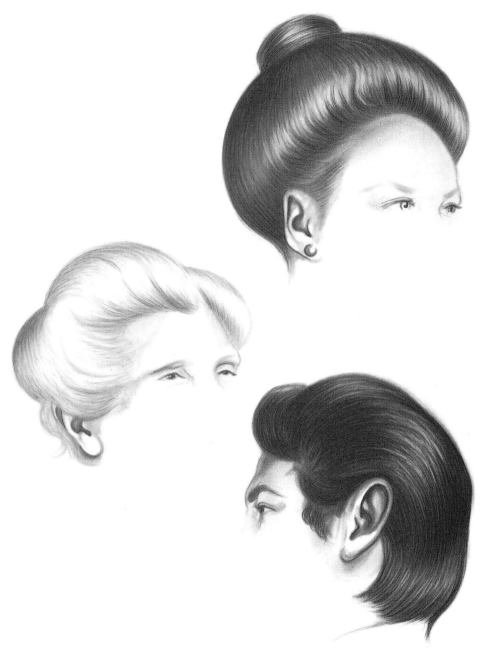

The roundness of this hairstyle is clearly indicated by the *band of light*, which is seen both on the front of the hair and on the bun on top. Notice how the pencil lines follow the direction that the hair is going, but they have been softened with blending, and the highlights pulled out "into" the dark areas.

The illusion of gray or nearly white hair is created by using less tone and fewer pencil lines, and doing more blending with the tortillon. The softness is a result of the highlight areas being lifted out. Hair color, as we learned when we were dealing with eye color, is represented by the shades of gray we use.

The highlights on this man's hair indicate a definite direction in which the hair is growing, and have been smoothly blended for a polished look.

Permed or Curly Hair

The fullness and varying hair direction of permed or naturally curly hair can be quite a challenge to draw. Since pencil lines should always be applied going in the direction of hair growth, you'll need to study your photo reference. It is not possible or necessary to capture every single detail. The important thing is to capture the overall fullness, with the suggestion of the types of curls the hair has.

It is also important to see how the hairstyle works with the face and neck, to see if it acts as a natural framework around it, and how the shadows cast by the hair affect the overall look.

This example was taken from the photo on page 100. By comparing the photo and these examples of the rendered hair, you can see where some of the areas have been simplified, while the basic shape and fullness have been maintained.

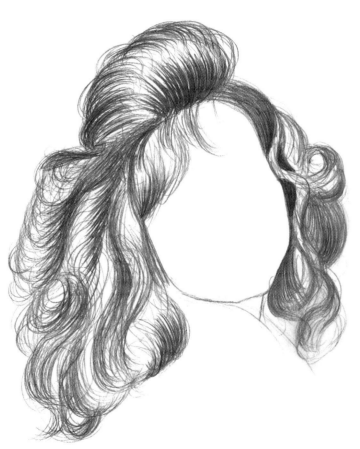

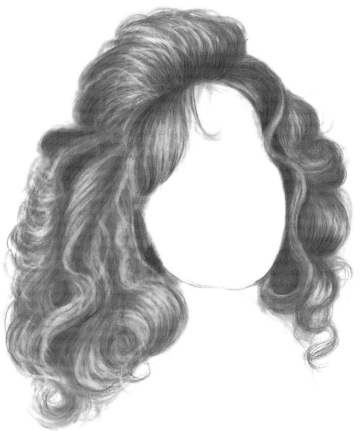

Step 1 DRAW THE SHAPES
The general direction of the various curls and waves has been drawn in with the pencil. Studying the shapes that the curls create, and squinting your eyes to see the dark tones, will help you create the fullness.

Step 2 BLEND AND LIFT HIGHLIGHTS
Blending keeps the hair looking soft. The highlights and individual strands of waves have been lifted with the eraser. This process must be repeated over and over to gain fullness. Each area that curves outward will have its own highlight area, or band of light.

The Band of Light

The band of light is clearly visible on this portrait. It helps describe the roundness of the forehead underneath the hair. Most portraits of babies and small children show this band of light quite clearly, since their heads are so round, and the bangs are straight and lay close to the head. By going back and reviewing the step-by-step portraits in chapter seven, you can see the band of light in the hair of those subjects too.

There is another band of light that can be seen on the ponytail. This will occur anywhere the hair is curved outward, reflecting more light. On curly or wavy hair, watch for this band on every curl or wave that curves outward.

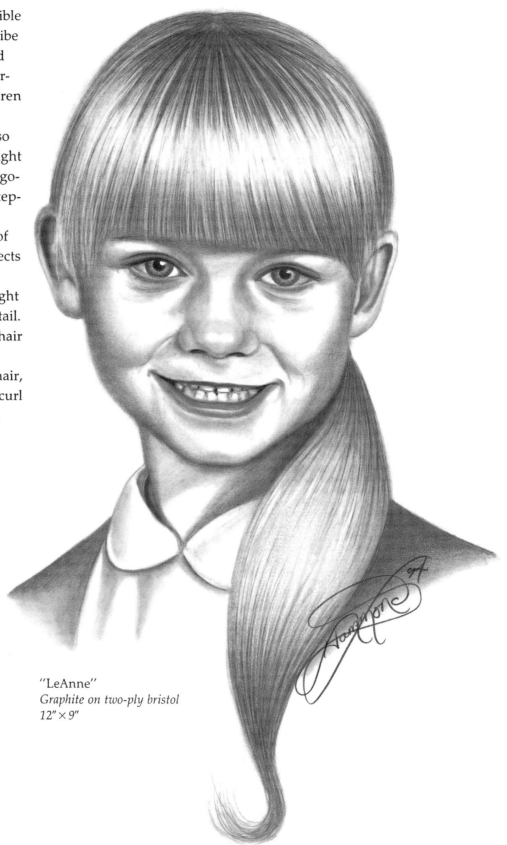

"LeAnne"
Graphite on two-ply bristol
12" × 9"

A Character Study

This is a beautiful example of how a solid understanding of rendering hair can add to the mood of a drawing. The definite light source coming from the right gently illuminates the beard, the hair and the hat. The light reflecting off these things makes you feel as if you could reach out and touch them.

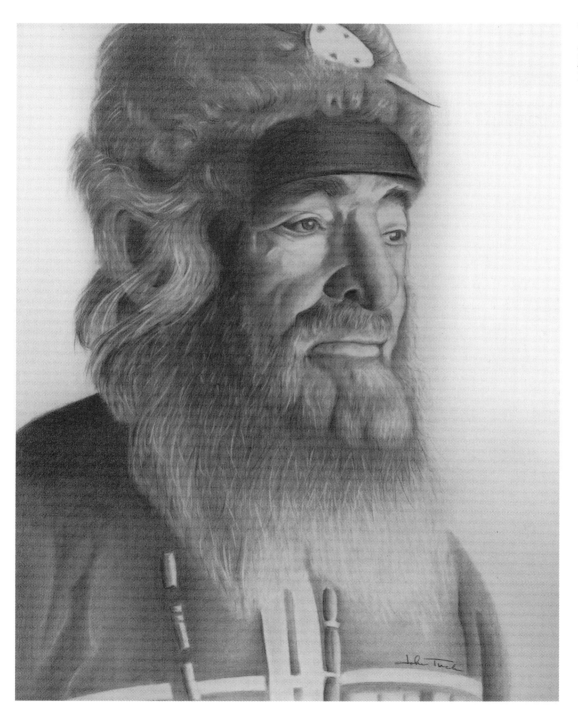

"Mountain Man"
Artwork by
John Tuck
14" × 11"

A Photo to Practice With

This photo will give you practice drawing all of the elements we have studied so far. It will offer you the challenges of a turned, angled face, an open smile with teeth, and permed, curly hair. But don't be overwhelmed. Take it a step at a time. Start by graphing the photo, then carefully draw the shapes of each facial feature, starting with the eyes. Finish with the hair, referring back to page 97 if you need help. We will be studying clothing in the next chapter, so for now, just sketch it in the best you can.

Important Points to Remember

1. In the beginning, draw the hair as one solid shape.

2. Start with the darks, laying in tone in the direction that the hair is growing.

3. Always blend out the entire mass, and build from there.

4. Each curl or wave has its own set of lights and darks, creating a band of light on each curl or area that curves outward.

5. Hair must be built up in layers.

6. Even permed or frizzy hair should be drawn in the direction of the hair growth. Use tight, circular strokes if necessary.

7. A band of light will be evident where the hair curves around the shape of the head.

8. Even white or gray hair is blended out, with the highlights lifted with the kneaded eraser.

9. The color of hair will be represented by the shades of gray that you use.

10. Practice!

11. Practice!

12. Practice!

How to Draw Clothing

Clothing can be a beautiful thing to draw. The combination of light and dark patterns created by the creases and folds gives the artist another unique challenge. Sometimes it is actually the clothing that makes the portrait interesting; it doesn't always have to be plain and simple. I chose the example at left because of the interesting folds and creases of the shirt and the effects of shadows on them.

It's important to watch closely for the areas of reflected light on the creases and folds. The shadow edges in conjunction with the reflected light is what makes the fabric come to life. Look for hard edges where the fabric overlaps. Soft edges are created where the fabric gently rolls.

The following pages explain the various types of folds and how to recognize them, and most importantly, how to use them to enhance the portrait you are working on.

The Five Basic Folds

There are five basic folds to look for when drawing fabric and clothing, each with its own set of characteristics. The following examples explain each of these folds and how you can recognize them.

A good understanding of folds is necessary to achieve realism in the clothing, and to keep the clothing from looking flat, as if it were painted on the subject.

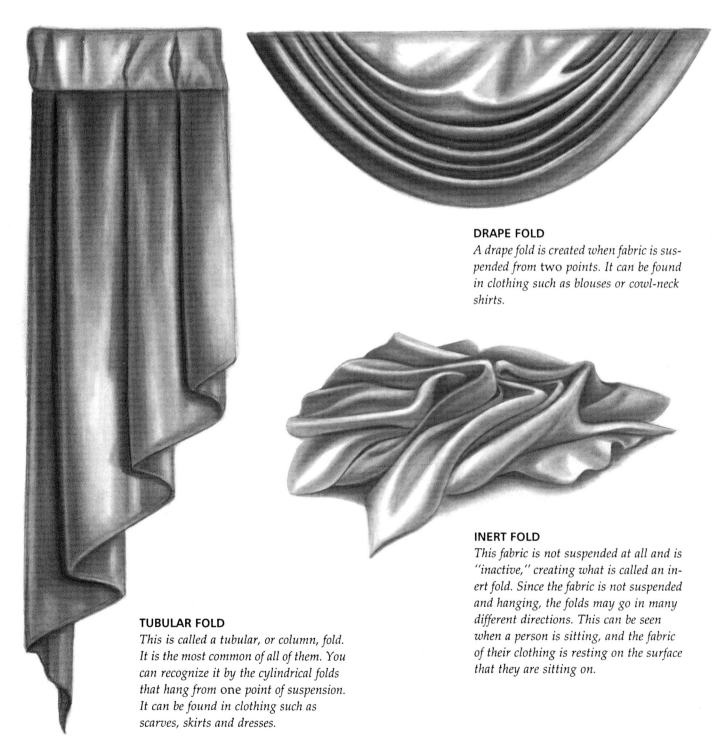

DRAPE FOLD
A drape fold is created when fabric is suspended from two points. It can be found in clothing such as blouses or cowl-neck shirts.

TUBULAR FOLD
This is called a tubular, or column, fold. It is the most common of all of them. You can recognize it by the cylindrical folds that hang from one point of suspension. It can be found in clothing such as scarves, skirts and dresses.

INERT FOLD
This fabric is not suspended at all and is "inactive," creating what is called an inert fold. Since the fabric is not suspended and hanging, the folds may go in many different directions. This can be seen when a person is sitting, and the fabric of their clothing is resting on the surface that they are sitting on.

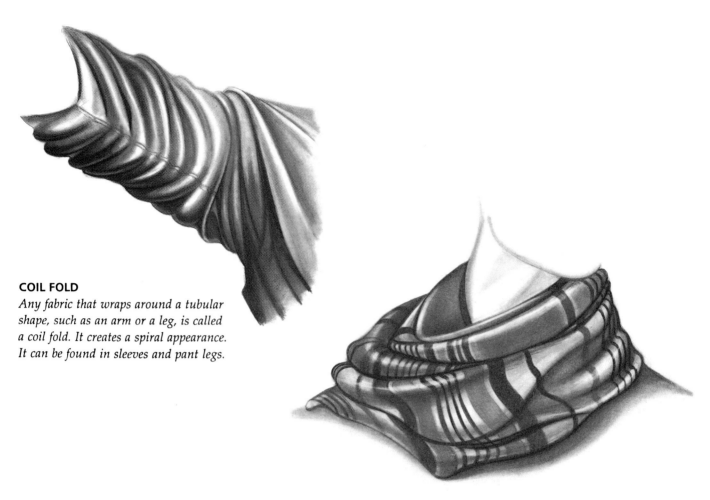

COIL FOLD

Any fabric that wraps around a tubular shape, such as an arm or a leg, is called a coil fold. It creates a spiral appearance. It can be found in sleeves and pant legs.

INTERLOCKING FOLDS

Sometimes fabric will create folds that are in layers, which actually sit inside one another. These are called interlocking folds, and are mostly seen when fabric is wrapped around areas like the neck. This is a good example of how the pattern of the fabric should be carefully observed and followed in and out of every layer, with shadows applied over them.

COMBINATIONS OF FOLDS

This illustration shows how fabric can create more than one type of fold at one time. This shoulder contains both interlocking and coil folds. Pay attention to where fabric is pulled or stressed, and look for the light and dark patterns created by the light source. The dark background helps create the light on the top of the shoulder.

Making the Clothing Work in Your Portrait

These drawings show how the clothing can lead your eye right to the adorable subjects. Both artists have done a wonderful job of keeping the stripes of the outfits following the contours of the figures, by allowing the stripes to go in and out of the fabrics' creases and folds. The addition of shadows helps create the roundness of form and adds to the realism.

It is not always necessary to keep the pattern of the clothing in your work. Unless it is essential to help tell a story about your subject, I suggest taking it down to a flat tone. This is especially true if the subject is wearing a bright plaid or loud print. However, should you decide to leave the pattern in, be sure to make the pattern follow the shapes that the fabric is creating.

"Sean"
Artwork by Kim McDuffie
14" × 11"

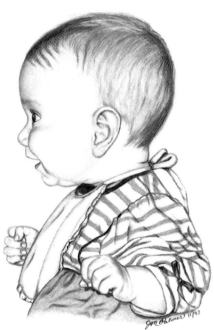

"Jessica"
Artwork by Judy Palmer
10" × 8"

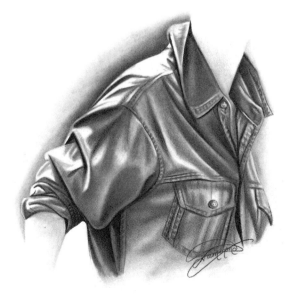

This picture has a definite light source, which highlights the fabric in an extreme way, making the contrasts very obvious and beautiful. The use of shadowing behind the subject adds to the contrasts of light and dark.

Important Points to Remember

1. Observe the five different types of folds.

2. Study the way the fabric is being pulled and stressed.

3. Look for the light source and see how it affects the folds and creases.

4. Look for the hard edges where the fabric overlaps, and the soft edges where it gently rolls.

5. Look for the reflected light and the shadow edges.

6. Use some background tone behind your subject matter if it will help create a more obvious light source.

7. Make sure that the pattern of the fabric is following the curves, folds and creases.

8. Remember to include the shading over the patterns to create shadows.

9. Practice!

10. Practice!

11. Practice!

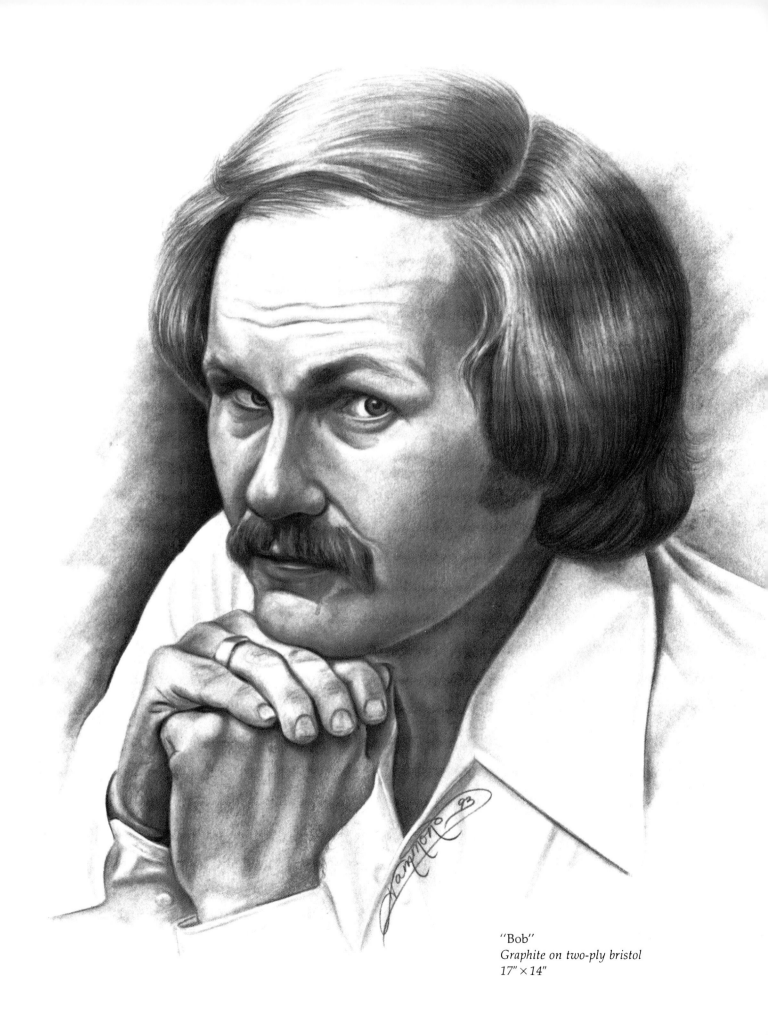

"Bob"
Graphite on two-ply bristol
17" × 14"

How to Draw Hands

Hands add mood and feeling to a drawing. As seen in the example at left, hands can change a regular portrait to a *character study*, a candid, unposed approach that reveals the subject's character and personality.

This drawing grabs your attention with the expressive eyes, while the pose of the hands settles the portrait into a serious mood.

Drawing hands is difficult for many artists. They are complex with smooth transitions of lights and darks and many overlapping shapes. Because of this, I see similarities in drawing hands and drawing fabric.

Most artists simplify the hands, ignoring their many angles. The result is hands that are much more rounded than they should be, creating an unnatural, rubbery look. The illustrations in this chapter will show you the angles that are created by the joints. Whether relaxed or outstretched, the fingers are never really straight. They always have subtle angles where the knuckles and joints create separate planes.

Simplifying the Shapes of the Hand

Do you remember the Puzzle Piece Theory we talked about at the beginning of the book? If not, review the material on pages 18-19 before starting this exercise. Drawing the shapes shown below in their corresponding numbered boxes on the empty graphs will prove that even if the hands are a problem area for you, you can do it!

Start with the simpler graph at top, then try the more complex one at bottom. Try not to draw from memory; just draw the nonsense shapes. (Make a photocopy of the graphs if you prefer not to draw in the book.)

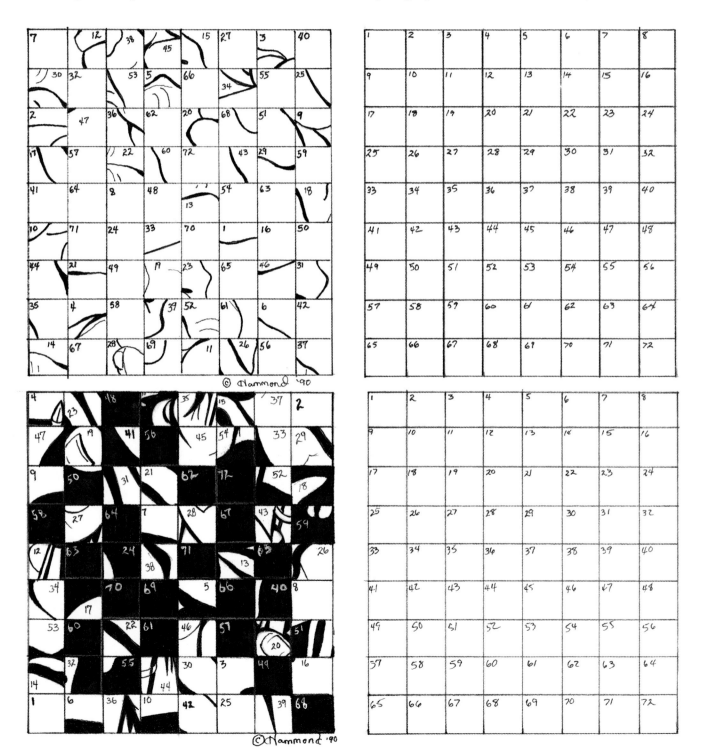

Comparing Men's and Women's Hands

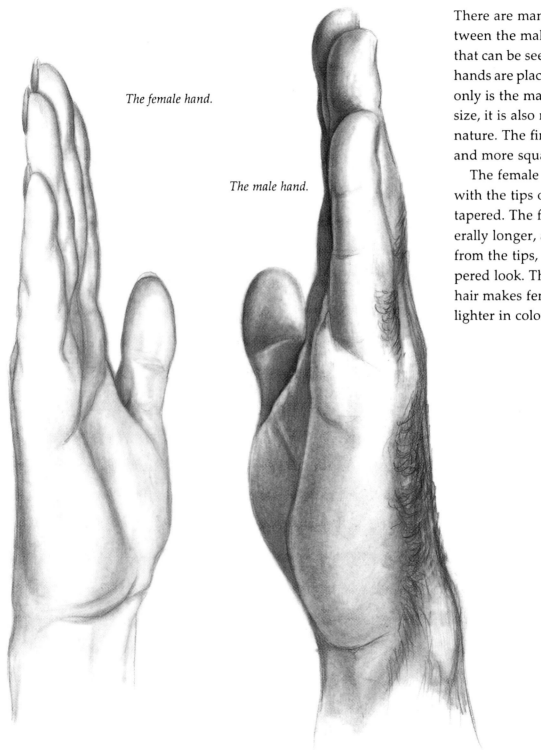

The female hand.

The male hand.

There are many differences between the male and female hand that can be seen clearly when the hands are placed side by side. Not only is the male hand larger in size, it is also much "boxier" in nature. The fingers are thicker and more squared off.

The female hand is slender, with the tips of the fingers more tapered. The fingernails are generally longer, and will protrude from the tips, adding to the tapered look. The absence of body hair makes female hands appear lighter in color.

Drawing the Female Hand

Outlining the hands is one of the most common drawing errors. By allowing the shades and tones to become edges rather than outlines, the hands will possess a more realistic quality.

The placement of tones on your line drawing is critical. It is here that you will see all of the shadows created by each finger, and the subsequent areas of dark over light and light over dark.

It is very important to study each finger and where it overlaps another surface. You can then create the edges necessary to separate the fingers from the surface below. This is done by softening the edge into the surface in which it belongs. For example, look at the dark edge that defines the bottom of each finger. This dark edge should be shaded and softened into the finger, rather than into the palm of the hand. This makes the dark area "belong" to the finger, rather than becoming a shadow underneath. See how the reflected light creates the roundness of each finger.

Graphing the Hand

This is an example of one of the most common hand and face poses. Use your graph and practice from this example, keeping in mind all of the information we have covered so far. Draw the entire photograph so you can study the relationship of the hand to the face, and the shadows that are created on the neck and chest.

To keep the hands in correct scale to the rest of the features, remember that the hand is about the same size as the facial plane. Place your own hand over your face with the palm at the base of your chin. The tips of your fingers will reach to about the middle of your forehead. Stretch your fingers out, and the width between your little finger and thumb will be about as wide as your face.

By looking at the jewelry as just "shapes," see how convincingly you can render it. If you need to, you can use your ½-inch graph to isolate the shapes more effectively.

The Angles and Planes of the Hand

Hands are really very angular in nature, not round and rubbery as we tend to portray them in our artwork. By comparing these line drawings, with the angles blocked in, with the fully rendered examples on the facing page, you can see how the joints and knuckles create various planes. By clearly defining these angles in your line drawing first, your hands will take on a more realistic form.

Keep your blending very gradual, and *never outline* the fingers.

Allow the shading to create your edges. Always ask yourself, "Where is it light against dark, and dark against light?" Look for the light areas that have been lifted out wherever the surface is somewhat raised.

The creases and lines in the hands are never harsh, but gently softened. The fingernails should be seen individually as shapes, with the light and dark patterns studied on each. The hair on the tops of the hands and on the arms is put in last with very light, quick strokes.

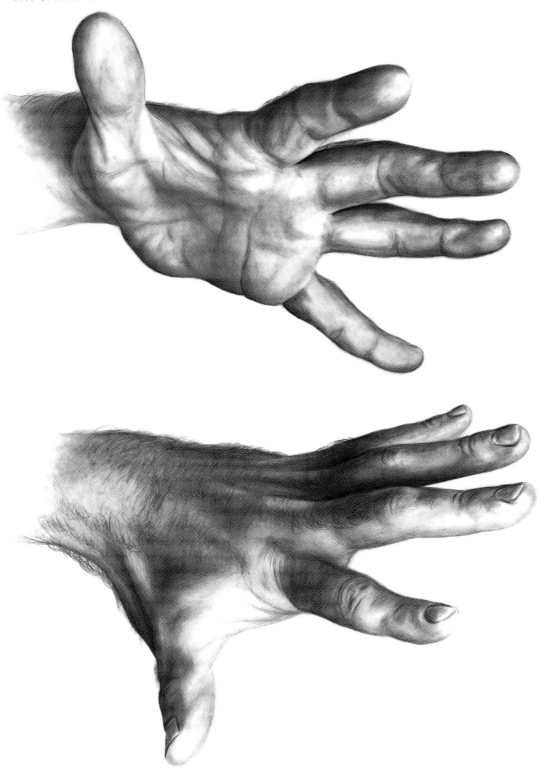

Drawing Hands Step by Step

Step 1 ANGLES AND PLANES

Your overall line drawing will be much more accurate if you keep the angle lines in mind while drawing. When you begin your shading, be sure not to lose these angles and make things appear too round.

Step 2 ACCURATE LINE DRAWING

Use your graph to isolate all of the distinctive shapes of the hand. This is where you must accurately draw in the many angles created by the pose.

Step 3 PLACEMENT OF TONE

Where is it dark? Where is it light? Place your darks carefully. Decide which "plane" they belong to, e.g., is it a dark edge of a finger, or is it a dark shadow beneath a finger?

Step 4 BLENDING AND LIFTING HIGHLIGHTS

Keep all blending extremely smooth. Blend your darks into the surface they belong to. Lift out highlights with your kneaded eraser. Be sure that reflected light is evident between the fingers to create roundness.

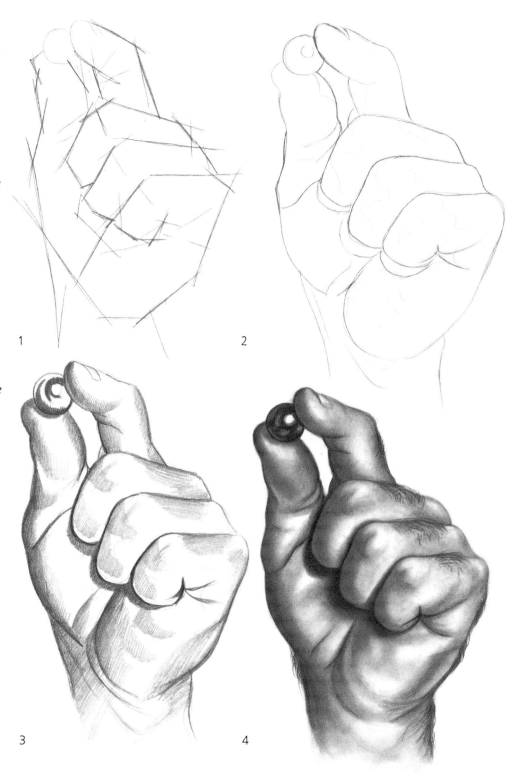

1

2

3

4

Expressive Hands

These portraits show how the hands can be used to enhance the visual impact of your artwork. Although any portrait of a baby is cute, the addition of the hands makes it that much more endearing.

Look at the overall shape differences between a baby's hand and an adult's. Be sure you capture the chubbiness and roundness of the form.

Below is a clear example of size relationships, with the smallness of the newborn accentuated by the father's hand. The use of the blended background helps define the light profile of the baby's face.

Both of these drawings were taken from everyday snapshots, and are examples of how your own photo album can become a gold mine of potential artistic expressions.

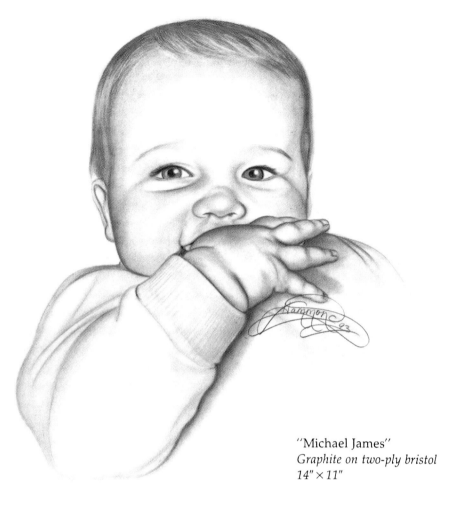

"Michael James"
Graphite on two-ply bristol
14" × 11"

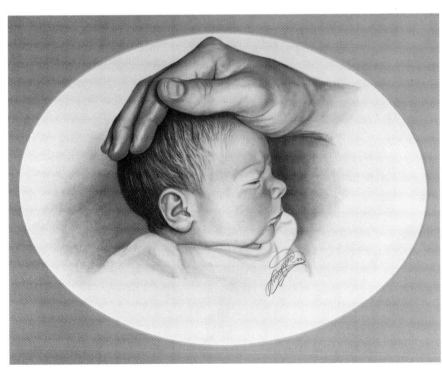

"Claire Marie's First Day"
Graphite on two-ply bristol
14" × 11"

A Finished Portrait

This portrait is one of my personal favorites. It shows how the use of hands and the contours of clothing can add to the essence of the artwork. The softness of the sweater cradling the baby leads the eye around the portrait, creating an oval composition. The father's hand gives the subject matter solidity. The tones of the composition are balanced: The darkness of the top of the head is counterbalanced by the darks underneath the arm and around the elbow.

"Criffy and Daddy"
Graphite on two-ply bristol 20" × 16"

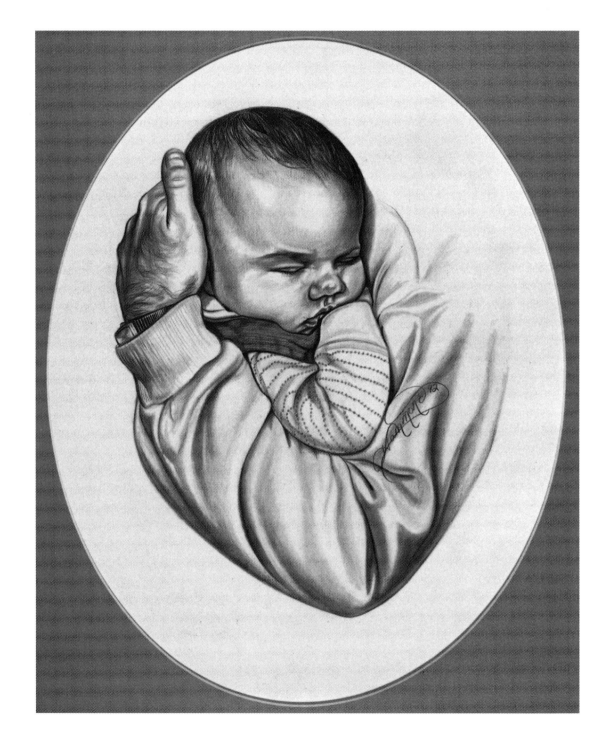

Important Points to Remember

1. Be sure to see—and draw—the angles created by the joints of the hand, to prevent an overly round, rubbery look.

2. Never outline the fingers.

3. Keep your blending very gradual.

4. Where is it dark, and where is it light?

5. Look for the edges.

6. Look for the reflected light on each finger.

7. Hands can add visual impact to a portrait.

8. The size of the hands can be compared to the size of the face.

9. Men's hands are "boxier" than women's.

10. Practice!

11. Practice!

12. Practice!

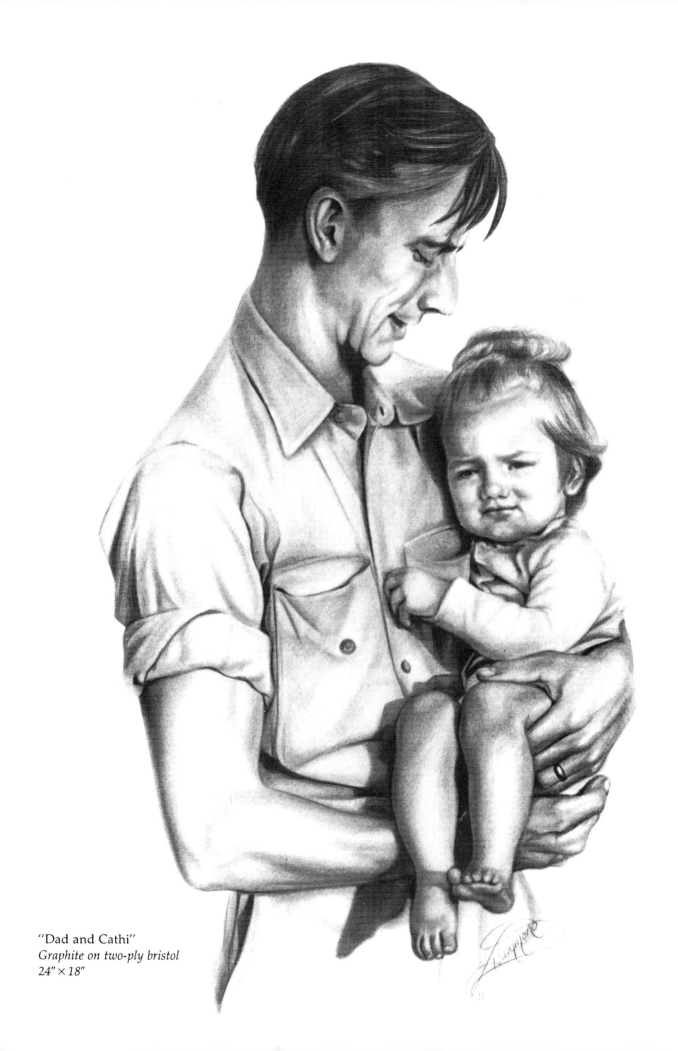

"Dad and Cathi"
Graphite on two-ply bristol
24" × 18"

Composition, Backgrounds and Special Effects

A portrait need not be limited to a single subject. Often the most expressive and revealing portraits involve two or more subjects. However, if you wish to add another subject, a background or a prop to your portrait, great care and consideration must be given to the placement of these things on your paper. They will strongly affect the overall balance of your composition. This chapter will give you some basic guidelines to follow as you begin to create more difficult pieces of work.

Since many times the subjects you want to draw are not always found together in the same photograph, this chapter will help you combine subjects from separate photos. Your creativity can be greatly enhanced when you know you aren't limited by your photo references.

Also, the ability to add interest through the use of special effects takes you from merely replicating photographs to truly creating art. This is when portrait drawing becomes exciting and fun to do.

Composition

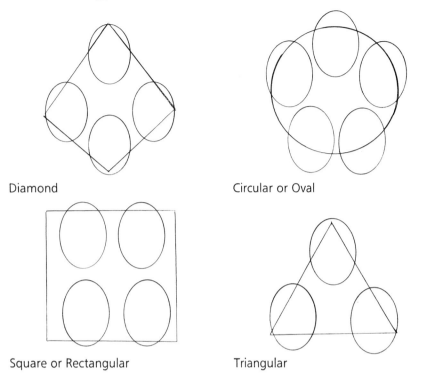

Diamond

Circular or Oval

Square or Rectangular

Triangular

Each compositional shape can have any number of subjects in its arrangement.

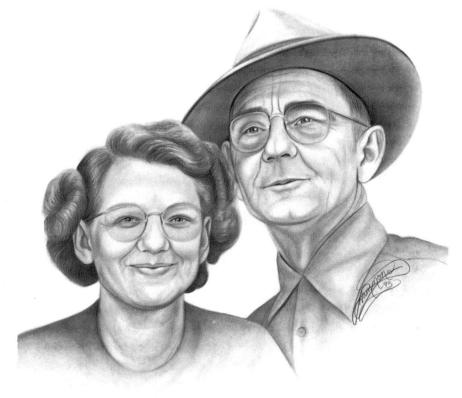

"Grandma and Grandpa Sigler"
Graphite on two-ply bristol
14" × 11"

Composition is simply the way in which your subject matter is placed on the page. One of the hallmarks of good composition is *balance*. A well-balanced portrait is one in which there is not more "weight" on one side of the paper than the other, or too much space on either the bottom or the top. Not only do the shapes of your subjects need to be in balance, but the tones do as well. Too many darks in one area will weigh it down and take the composition out of balance.

There are four basic compositional shapes to keep in mind for portraiture: triangular, circular, square or rectangular, and diamond. These are the patterns created by the way you place your subjects on the page. If one of these shapes is the foundation for your work, the viewer's eye will be led around the page to the center of interest, or the focal point. Never allow the placement of shapes or the pose to send the viewer's eye outside of the picture plane.

The portrait at left was created by placing two subjects together that were not actually side by side in the reference photo. It is a triangular composition, pointed at the top because of the hat, and wider at the bottom due to the shoulders. The top of the woman's head is across from the eye level of the man, giving them the conventional size relationship.

Multiple Subjects

It's not necessary for the subjects you're drawing to be in the same reference photo, but there are certain guidelines you should follow when combining photos.

1. Make sure the lighting is consistent in both photos. If the lighting does not come from the same direction in each photo, the shadows on the faces will not match. Although it is possible to alter the lighting, it may be difficult, since shadows will alter the appearance of shapes.

2. Have your subjects looking in the same general direction. You can change the direction of the eyes by moving the placement of the irises.

3. Create a composition with the placement of your subjects. Use one of the four compositional shapes shown on the facing page.

You can combine subjects from different photos even if they are not the same size. Start with the largest subject first, and measure the distance from the mouth to the eyes. Then try to make the other subjects conform to those measurements.

If the subjects are of different ages, remember the natural size differences, and adjust your drawing accordingly. For example, if you're putting a photo of a small child with that of an adult, find out how much smaller the child's head would be in real life, by either measuring from photos of the two together, or by looking at them together side by side.

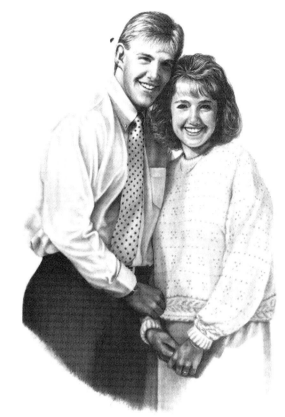

"Young Love"
Artwork by
Barb Teerlinck
20" × 16"

This pose is nicely arranged, with the top of the female's head in line with the eyes of the larger subject. By fading out the bottom of the portrait into an oval composition, the artist has created a very pleasing piece of artwork.

"Mom and Dad"
Artwork by Jim Ferguson
10" × 8"

This portrait breaks the rules I normally use for posing. I usually stagger the placement of the subjects' heads, but this straight-across pose works. The inward tilt of the heads leads the viewer's eye to the center, creating a triangular composition. This is more of a character study than a portrait.

Turn Moments and Memories Into Artwork

When looking for subject matter to draw from, look at your photograph and ask yourself if it can be arranged into a pleasing composition. Sometimes the placement or distraction of surrounding objects will make it difficult to work with.

I picked this piece to do because of its sentimental value. However, the photograph was not easy to work with. There were many items in the photo that I chose to leave out. Not only were there many windows and plants in the background, there were a table and chairs in the foreground. I chose to concentrate just on the people, so the full impact of the tender moment was the focal point without anything detracting from it. The arrangement ended up in a triangular composition.

"Shelly With Her Grampa"
Graphite on smooth mat board
20" × 16"

The grainy texture of Grampa's shirt was achieved by using the smooth mat board. It has somewhat of a "toothy" surface, and kept the shirt from looking shiny.

As a mother, I use my artwork as a way to chronicle my kids' development and remember their special personalities. I have found that by drawing from photographs of my children, I seem to remember more about them. I can look at photos of my oldest daughter, who is an adult, and remember quite well what she used to look like. But when I take one of those pictures and begin to draw from it, memories come flooding back, and I can actually "feel" the way she was. It seems to unlock a source of deep emotions that have been stored away over the years.

When traveling, I try to sketch various scenes, as well as take photos. The pictures I have drawn will always bring back more memories than will the photos, right down to the feelings and smells involved with that particular moment.

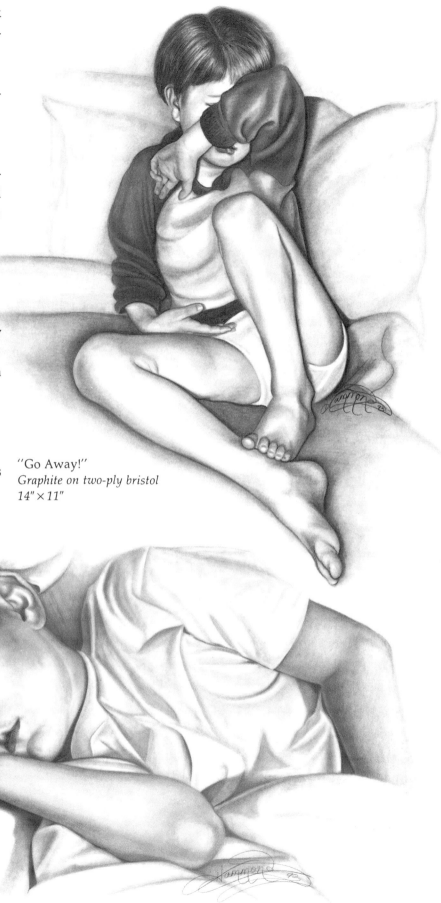

"Go Away!"
Graphite on two-ply bristol
14" × 11"

"Christopher at His Best"
Graphite on two-ply bristol
14" × 17"

Creative Backgrounds

The use of a background can play an important part in the visual statement you want your work to express. You can give it a soft, calm look, or liven it up with a graphic, energetic approach. Either way, you should be sure that it works *with* your subject matter, and never takes away from it.

Concentrate on the lights and darks of your subject when selecting a background treatment. If the subject is very light on one side, some dark tone behind it will show the contours more clearly. Always pick a background that will show off the contrasts. I use the *light against dark and dark against light* guideline.

Try to keep your background shading *below* the eye level of the subject. Shading applied over the top of the head will weigh the subject down.

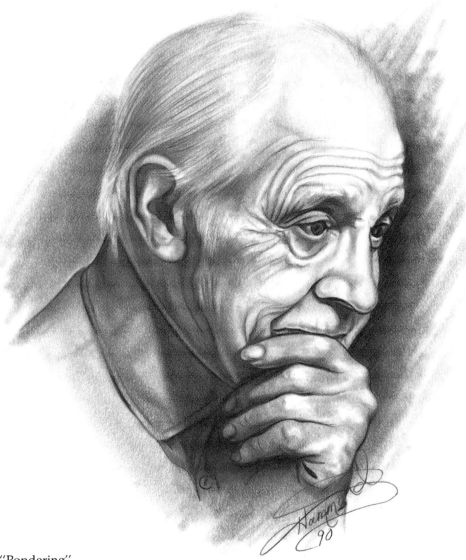

"Pondering"
Graphite on two-ply bristol
11" × 14"

This portrait needed something to make it stand out. The light source on the face made it necessary to put in a background to help define the edges of the face and hand. But when I put in a smooth background, it seemed too calm. I wanted to give it a striking, masculine appearance, to help give the subject more personality and intensity. The bold, streaked background gives the portrait life and a rugged, masculine look.

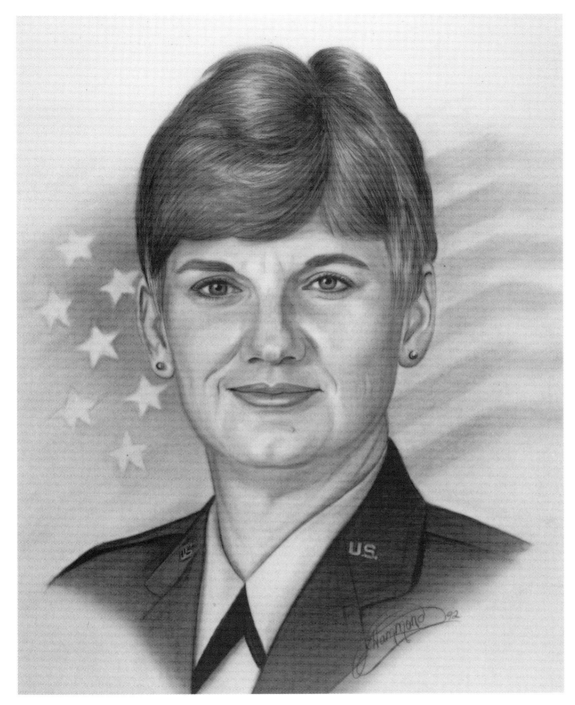

"Cathi"
Graphite on two-ply bristol 14" × 11"

I drew this for my sister when she joined the Air Force. The background is a unique way to make a statement about her and convey a patriotic sense.

Sometimes you will want to include a realistic background, or the actual surroundings of your subject as seen in the photograph you are using. This can make for a very nice piece of artwork, actually helping it tell a story by creating atmosphere. In the drawing on the next page, I wanted to include the bricks and the faint handrail in the distance to show that the scene takes place on my front porch. It gives the impression of a relaxing afternoon at home. Had I just drawn my little boy sitting in the chair, with a plain or blended background, it would have been a little boring, and the theme of the picture would have been lost.

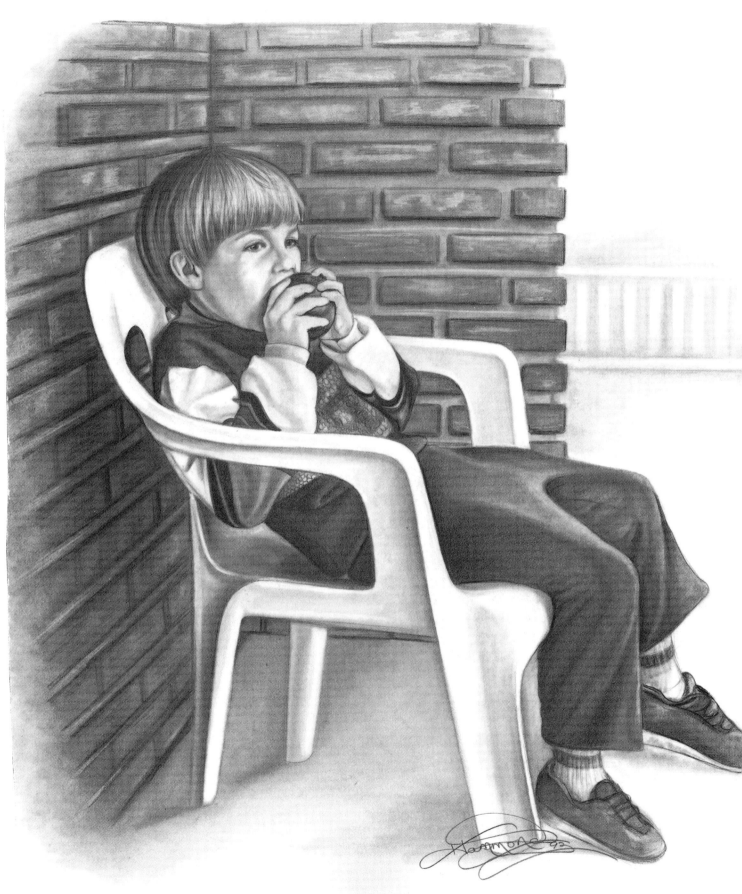

"Just Relaxin'"
Graphite on two-ply bristol
16" × 12"

Cropping

Cropping is a technique that involves framing the drawing within a border, and is an effective and even dramatic way to present your subject.

On the portrait of Clint Eastwood, the border actually cuts off some of the image, allowing very little background to show. I was careful about the balance of shapes and tones, making sure there was enough empty space to offset the darkness of the larger shapes.

A border can be actually drawn in, or it can be created with *border tape*. This adhesive tape comes in various widths, colors and even patterns and can be purchased at art stores. Although I do use a lot of border tape, I usually reserve it for artwork that is going to be printed. The tape will become loose with the passing of time, and should be used for temporary applications.

At right is another example of cropping, but rather than using a border, the artist placed the image on the page so it goes clear to the edges of the picture plane. This creates a triangular composition, and also balances the tones.

This portrait is also an effective use of extreme lighting. The strong light source illuminates the face and creates beautiful shadows and highlights in the hair. The subtle application of tone behind the subject helps define the edges and contours of the face, and allows the face to be in the strongest light.

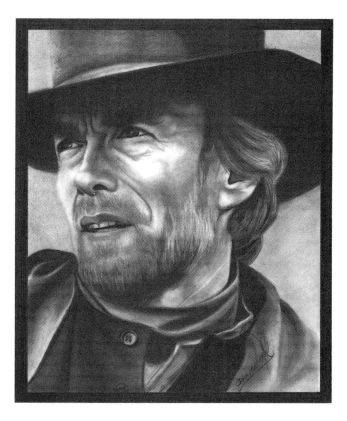

"Clint Eastwood"
Graphite on two-ply bristol
10" × 8"

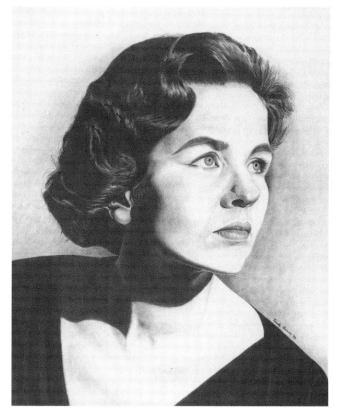

"Brigitte"
Artwork by Trudy Brown
14" × 11"

Assembling a Montage

A portrait can range from simple, to enhanced, to downright complex! This is what is called a *montage* and shows how you can go to extremes by including a lot of subject matter in one portrait. It is the same principle as cutting pictures out and pasting them together on a page, like we did in school. The difference is, this time you draw it instead of gluing it together.

A montage is a nice way of telling a story about someone, preserving their life through your artwork. The montage below is a group of memories about someone who meant a lot to me as I was growing up. After he died, I realized I had no pictures by which to remember him and his farm, except for a formal portrait taken of him and his kids. In that picture, he was wearing a suit and tie, and I had never seen him in anything other than jeans and a cowboy hat. I wanted to somehow immortalize him the way I always knew him to be.

By going through my reference pictures of men and horses, I was able to compile a group of pictures that would help me tell the story. I found a man with a cowboy hat, and was able to draw the hat on Bob, and duplicate the shadows created on the face. I was able to change the girl on the right into *me*, and keep the other subjects somewhat generic.

The result was better than I thought it would be. Although it makes me a little sad when I look at it, it will always be one of my favorite drawings, because of the memories and sentiment it invokes. Bob always liked my artwork. I think he would be pleased!

"In Memory of Bob DeVoogd"
Graphite on two-ply bristol
24" × 18"

Important Points to Remember

1. Your artwork should be balanced both by shapes and by tones. Use one of the four general compositional shapes: triangular, oval or circular, square or rectangular, or diamond.

2. Never let the subject matter or composition lead the viewer's eye outside the picture plane.

3. Portraits are posed; a character study is candid.

4.. When combining subjects from different photo references, look for three things: size relationships, consistent lighting and eye direction.

5. Background treatments should enhance your work, not compete with it.

6. Use light against dark and dark against light tones in your background.

7. Do not shade above the head—it will weigh the subject down.

8. Eliminate unnecessary subject matter that may be in your photo so it does not detract from your center of interest.

9. Cropping your artwork can create an interesting and dramatic portrait.

10. Practice!

11. Practice!

12. Practice!

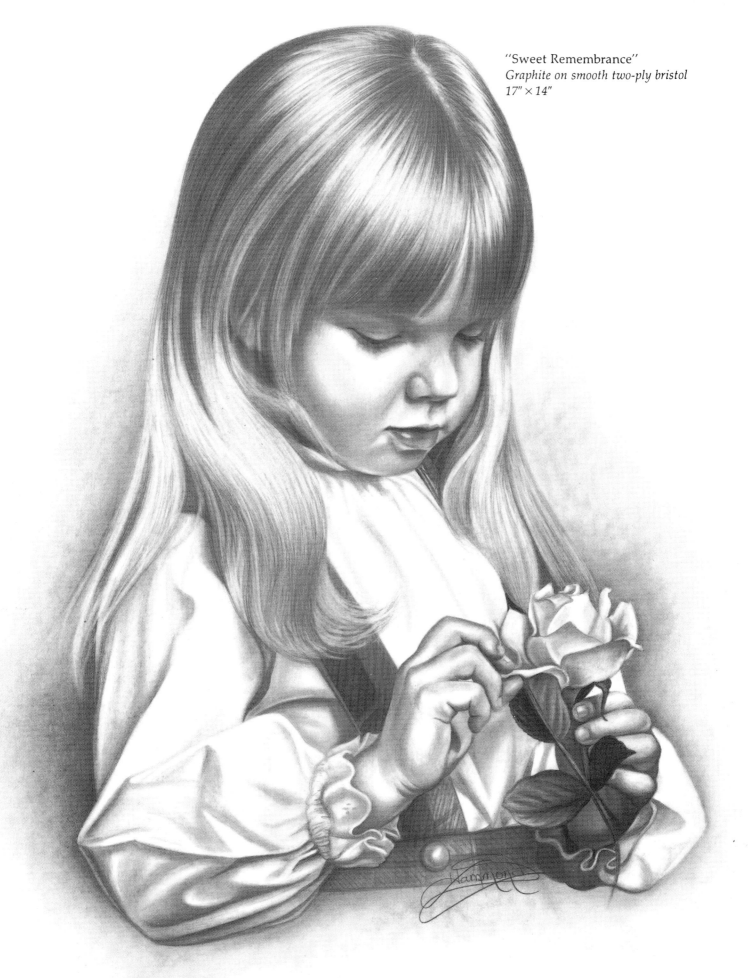

"Sweet Remembrance"
Graphite on smooth two-ply bristol
17" × 14"

Conclusion

So, where do we go from here? The possibilities, I believe, are endless. When I was compiling the information and material for this book, it seemed to take on a life of its own, with more ideas than I could possibly keep up with. We have covered just the tip of the iceberg within these pages. The rest of the adventure is up to you.

The skills and information that you are now armed with will provide you with all you need to know to develop the style and courage necessary to be truly creative. Not only have the secrets of portrait drawing been revealed, but the process for rendering *all* subject matter realistically is now at your fingertips. If you have learned anything from this book, I hope it is that *any* subject matter can be drawn using this approach. It really doesn't matter if you are drawing a person, a tennis shoe, or a still-life arrangement, the same principles will always apply.

I hope that the creative dam has now been broken for you, and that a flood of ideas and excitement about your artwork will flow through you, enhancing not only your skills, but also your life! The best of luck to you always.

Lee Hammond

INDEX

More Great Books for Beautiful Art!

First Steps Series: Drawing and Painting Animals—Discover how easy it is to draw and paint favorite pets, barnyard critters and wild animals. You'll learn how to simplify the process into easy-to-do steps—from creating basic shapes to adding the necessary details that will bring your creation to life! #30849/$18.99/128 pages/96 color illus./paperback

Basic Colored Pencil Techniques—Follow along with clear and easy demonstrations as you explore the foundational techniques of this expressive medium. From layering to burnishing, you'll learn a variety of versatile techniques and how to apply them to create trees, flowers, animals, people and other popular subjects. #30870/$17.99/128 pages/173 color illus./paperback

First Steps Series: Drawing in Pen & Ink—Now you can draw sketches that actually look like your subjects! Popular instructor Claudia Nice guides you through step-by-step projects and simple techniques for creating realistic-looking trees, flowers, people and more. #30872/$18.99/128 pages/200 b&w illus./paperback

How to Draw Portraits in Colored Pencil from Photographs—Create colored pencil portraits that only *look* as though they were difficult to draw! Professional portraitist Lee Hammond takes you from start to finish with simple instructions, color recipes, layering techniques and inspiring demonstrations. #30878/$27.99/128 pages/261 color illus.

Sketching Your Favorite Subjects in Pen & Ink—The first complete guide for all types and levels of artists on sketching from life in pen and ink. Written by Claudia Nice, a master of the subject, this book is presented in an easy-to-follow, step-by-step fashion. #30473/$22.99/144 pages/175 b&w illus.

How to Get Started Selling Your Art—Turn your art into a satisfying and profitable career with this guide for artists who want to make a living from their work. You'll explore various sales venues—including inexpensive home exhibits, mall shows and galleries. Plus, you'll find valuable advice in the form of marketing strategies and success stories from other artists. #30814/$17.99/128 pages/paperback

Creating Textures in Pen & Ink With Watercolor—Create exciting texturing effects—from moss to metal to animal hair—with these step-by-step demonstrations from renowned artist/instructor Claudia Nice. #30712/$27.99/144 pages/120 color, 10 b&w illus.

Drawing Expressive Portraits—Create lifelike portraits with the help of professional artist Paul Leveille. His easy-to-master techniques take the intimidation out of drawing portraits as you learn the basics of working with pencil and charcoal; how to draw and communicate facial expressions; techniques for working with live models and more! #30746/$24.99/128 pages/281 b&w illus.

1999 Artist's & Graphic Designer's Market: 2,500 Places to Sell Your Art & Design—Your library isn't complete without this thoroughly updated marketing tool for artists and graphic designers. The latest edition has 2,500 listings (and 750 are new!)—including markets such as greeting card companies, galleries, publishers and syndicates. You'll also find helpful advice on selling and showing your work from art and design professionals, plus listings of art reps, artists' organizations and much more! #10556/$24.99/720 pages/paperback

First Steps Series: Sketching and Drawing—You'll find great advice for beginning artists on how to draw believable trees, fruit, flowers, skies, water and more. Simple step-by-step directions and demonstrations show you how to put it all together into a finished product. Also included are easy and useful tips for blending, shading, perspective and other techniques to help you create realistic drawings. #30719/$18.99/128 pages/121 b&w illus./paperback

Creating Textures in Colored Pencil—Add new dimension to your colored pencil work with these techniques for creating a rich variety of texture effects. More than 55 lifelike textures are covered, using clear, step-by-step demos and easy-to-do techniques, plus special tricks for getting that "just right" look! #30775/$27.99/128 pages/175 color illus.

Basic Figure Drawing Techniques—Discover how to capture the grace, strength and emotion of the human form. From choosing the best materials to working with models, five outstanding artists share their secrets for success in this popular art form. #30564/$16.99/128 pages/405 b&w illus./paperback

Keys to Drawing—Proven drawing techniques even for those of you who doubt your ability to draw. Includes exercises, chapter reviews and expressive illustrations. #30220/$22.99/224 pages/593 b&w illus./paperback

The Pencil—Paul Calle begins with a history of the pencil and discussion of materials, then demonstrates trial renderings, various strokes, making corrections and drawing the head, hands and figure. #08183/$22.99/160 pages/200+ b&w illus./paperback

The Complete Colored Pencil Book—Bernard Poulin's comprehensive book offers everything from how to buy the right tools, to how to draw rich landscapes and create textures, to how to outfit a portable studio. #30363/$27.99/144 pages/185 color illus.

The Very Best of Children's Book Illustration—Spark your creativity with nearly 200 reproductions of the best in contemporary children's book illustration. #30513/$29.95/144 pages/198 color illus.

The Colored Pencil Artist's Pocket Palette—This handy guide packed with color mixes ensures you'll pick the right colors every time! #30563/$16.95/64 pages/300+ color illus.

Realistic Figure Drawing—Based on the principles of drawing first established in the Renaissance, author Joseph Sheppard shares his technique in this illustration-packed book. #30305/$19.99/144 pages/200 b&w illus./paperback

Creating Radiant Flowers in Colored Pencil—With the right combination of colors and basic techniques, artists can capture the rich textures and personalities of elegant orchids, graceful roses, cheery pansies and dozens of other beautiful blossoms. #30916/$27.99/128 pages/181 color illus.

A Step-by-Step Guide to Drawing the Figure—Artists of all abilities will appreciate this easy-to-follow manual to figure rendering. With more than 400 color illustrations, this book details literally every component of drawing the figure—from choosing the right materials to creating a setting. Drawing exercises accompany the description of each technique. #30902/$24.99/128 pages/450 color illus./paperback